The Banff Purchase

 JOHN WILEY AND SONS CANADA LIMITED, TORONTO

An exhibition of Photography in Canada

The Banff Purchase

Design by Brant Cowie/Artplus
Colour separations, scanning and printing by Herzig Somerville Ltd.
Bound at The Bryant Press Ltd.

This book features 200-line screen four colour reproductions and varnished 200-line screen grey-black duotones printed on 100 lb. Warren Flokote gloss stock.

CANADIAN CATALOGUING IN PUBLICATION DATA

Banff Centre
 The Banff purchase

Catalogue of a travelling exhibition of photographs from the collection of the Banff Centre.

ISBN 0-471-99829-X

1. Photography, Artistic — Exhibitions.
2. Banff Centre. I. Title.

TR646.C32B35 779'.0971'074011233 C79-094282-4

Printed and bound in Canada
10 9 8 7 6 5 4 3 2 1

Contemporary Photography by

David McMillan

Nina Raginsky

Orest Semchishen

Robert Bourdeau

Tom Gibson

Charles Gagnon

Lynne Cohen

THE BANFF PURCHASE includes the work of several of the most accomplished members of a generation of Canadian photographers whose images began to be seen in the early and mid 1970s with the increase in galleries and museums exhibiting photography in this country. They succeed Lutz Dille, Michel Lambeth, John Max and other Canadian photographers in the social documentary tradition, access to whose work was provided principally by the exhibitions and publications produced by the Stills Division of the National Film Board in the late 1960s. While the work of Nina Raginsky might be said to span both periods, David McMillan, particularly, belongs chronologically to that group of younger photographers living in Canada whose work is just now beginning to receive attention.

That *The Banff Purchase* represents, in part, a generation of photographers, does not mean that the groups of images seen here are not characterized by distinct approaches to photography. This selection of images indicates the extent to which, at this point in its development, photography is able to support, simultaneously, heterogeneous ways of understanding its use as a medium of expression.

This collection indicates a concern on the part of Canadian photographers with often unpeopled expanses of the natural and social landscape. Beyond this, what emerges as common to these images is a particular physical distancing from the surroundings and events portrayed; this holds true whether or not these surroundings and events reveal themselves as the real or primary subject matter of the photographs in question. However, the point around which discussion of these photographs might prove important has to do not so much with the physical, but with the psychological and philosophical distancing of the photographer and the viewer from the environments or persons pictured, and with the ways in which this is manifested by varying uses of photography's image-making potential.

The photographs of Orest Semchishen evoke the nostalgia of small Albertan towns. Semchishen presents aspects of the visual vernacular — hand-painted commercial signs and indigenous architecture like western false store fronts — which refer to a vanishing way of life. It is sometimes only the inclusion of late model cars and television antennae in the image that makes us realize that we are not in the era of the blacksmith. As with several

Introduction

of Semchishen's other series, portraits of Edmonton business people and studies of Byzantine churches, these images are highly specific with regard to time and place. Their import as historical documents should not obscure their power to convey a sense of the spirit animating these communities. It is with no little wit that the photographer intimates something of the texture of contemporary life in Okotoks or Bellis with the suggestion of human activity about to emerge from behind curtains and bushes that hide houses from the street.

The physical distancing from the subject matter in these photographs echoes the expanse of the prairies and may, as well, be acknowledgement that while these streets and buildings can hint at the secrets of the past, they are unable to reveal them; in this sense the photographer is removed in time from what he photographs.

These oases of culture rooted in the vast and empty prairies may be understood as the actual content of Semchishen's photographs; there is nothing in them which proposes that the objects pictured are symbolic, nor is the viewer aware of a critical stance on the part of the photographer. Semchishen's documentation of what he considers to be these towns' salient features is executed in such a way as to indicate the great value he attributes to them as creative and positive, if sometimes humorous, vestiges of society's endeavours. Our taking these images to function primarily as visual traces of a cultural reality relies on our acceptance of photography's functioning primarily as an accurate transcription of physical reality.

It is instructive to relate the black and white portraits which Nina Raginsky made in the 1960s with the equally frontal, sepia-toned, hand-coloured portraits reproduced here. The genre of individuals admitted to Raginsky's pantheon has remained the same — compare the earlier image of a cassocked vicar and his vintage Bentley with that of the tweed-coated and sensibly-shoed middle-aged sisters outside Victoria's Empress Hotel made in 1975. The colour she applies underlines how singular the persons represented are, returning the photographic portrait to its origins as a cult object that literally reflects the image of the loved one. The photographs establish a typology of persons which the colour situates in the realm of memory. This memory is collective since the photographer's cast of characters largely corresponds to traditional models of English Canadian society; the portraits are at

once of prototypes and their referents. The past which is recreated in these photographs is also a personal one. We may speculate about the significance of the images of children, their impenetrable world and the fact that they alone are not frozen into archetypes. The coloured portraits call into question the apparent objectivity of their black and white predecessors; and they distance the viewer from their subject matter both in time and by identifying their content as more symbolic than literal.

That the nature and disposition of objects in public and private space may be valuable indices of our collective and individual preoccupations is an underlying premise of the photographic activity of Lynne Cohen. Cohen's documents of unpeopled interiors provide a catalogue of contemporary living and gathering places — beauty salons, banquet halls, offices, clubs, restaurants and middle class living rooms. One appropriate response to her images would be on the order of ethnological inquiry. They afford the opportunity for a multitude of observations about popular, often anonymous arrangements of artifacts in space: in the examples Cohen provides of contemporary interiors, meticulous and obsessively symmetrical organization of objects is common, the caricature of the human figure is ubiquitous and visual hyperbole and synecdoche abound. Cohen's photographs allow for the formulation of hypotheses regarding the phenomenon of popular visual expression. In this sense their meaning is not bound to particular times and spaces nor to the realism of photography alone; but has instead to do with abstract constructs. It seems clear that the photographer is ideologically dissociated from the acquisitiveness she photographs. It is the perception of anthropomorphism in the construction of such an assortment of ordinary environments which lends Cohen's photographs their irony and sad humour.

In Tom Gibson's images solitary individuals seem totally unaware of the rationale underlying the complexity and precision of arrangement of the mazes of steel and glass, concrete and neon, mirrors and billboards, wires and posts which surround them. In many of the photographs people are seen carrying or wearing objects which, in the context of these images, come to take on the sense of totems, props in a ritual invented to ward off the presence of other people as well as awareness of the world around them. Everywhere, on the backs of sweaters and the facades of buildings,

images of a collective psyche seem to have materialized for those who have no inkling of their symbolism. The people in these photographs seem unconscious of both the transparency of their rituals and of how incredibly funny these can sometimes be. The geometry of the urban landscape in Gibson's photographs indicates a complex of decisions that its inhabitants have made and then perhaps forgotten. Gibson demonstrates that the selective process intrinsic to photography makes possible the presentation, together, of a series of similar gestures and juxtapositions. These create a structure of meaning in which the situations and objects pictured take on metaphorical significance. This meaning may differ from, or reinforce, the meaning that the photographs bear when seen as individual images.

Charles Gagnon's photographs describe a world composed of surrealistic tableaux found in disconcertingly empty streets, a world from which people seem estranged. The mysterious, altar-like configurations of objects in the landscape that are a *Leitmotif* of these images are usually constructed of artificial materials: piles of dirt, garbage bags or sod for an instant lawn; they mark an imposition of human order on the environment. As has been said of Atget's photographs, the images suggest evidence left at the scene of a crime; here the offense is the subversion of a fundamental order of things. Each photograph represents a moment of heightened awareness, a *Gestalt*, the recognition of a language with which we leave messages for ourselves out in the world. Many propose exits — doors, windows and other openings — implying that what is shown is a curtain through which one may pass to another, presumably less alienating way of being. The recurring windows both emphasize that seeing reveals the significance underlying the relation of objects in our surroundings, and allude to the perceiving consciousness of the photographer. Gagnon's photographs are not only metaphors for a mode of existence from which we have distanced ourselves, they are equivalents, maps of an interior landscape.

There is a sense in which the work of Robert Bourdeau supports an understanding of photographs of the natural landscape which has been common in this century: they are very often perceived to be evidence of a force which orders the natural world, and which as a result may be taken as a source of reassurance by the viewer. It is possible to take comfort from the continuity of human existence and spiritual yearnings suggested by Bourdeau's images of the Sri Lanka statuary. But it is also possible to feel irrevocably distanced

from the age and the world-view they reflect. Less ambiguous and more disquieting are the photographs of the landscape — those made in Utah more so than those of the English or Ontario countryside — which force us back to a sense of alienation from the reality exterior to ourselves. As with some of the United States geological survey photographs of the late 1800s, the natural phenomena which are the centre of energy in the frame appear to be where they are by virtue of a logic and a time frame having little to do with the persons who observe them.

A previous series of works by David McMillan compares photographs of situations set up by the photographer with identical views which, when looked at through a stereoscope, give the illusion of three dimensions. Within these images are to be found, in groupings of three, cut-outs of the letter "D". The same kinds of playful references to visual perception and to conventions of picture-making inform McMillan's more recent colour photographs. Bushes and signs obscure our view of postcard-perfect cityscapes of the genre often associated with colour photography. There a sense of ambiguous space, or a "what's wrong with this picture?" conundrum — a cord ties together a signpost and its shadow. The grid formation to which the city's information is made to conform mimics the asethetics of high art; it also serves to divide these photographs into a number of component images which appear interchangeable, arbitrarily locked together. With their heightened sense of space and colour these photographs are like dioramas. It is not what these photographs are of that constitutes their primary content. They are concerned with addressing photography as an image- and object-making device with its own perceptual and historical biases. In McMillan's photographs what is most pronounced is the distancing from subject matter and the suspension of the denotative function of photography.

PENNY COUSINEAU
University of Ottawa

The Banff Purchase

David McMillan

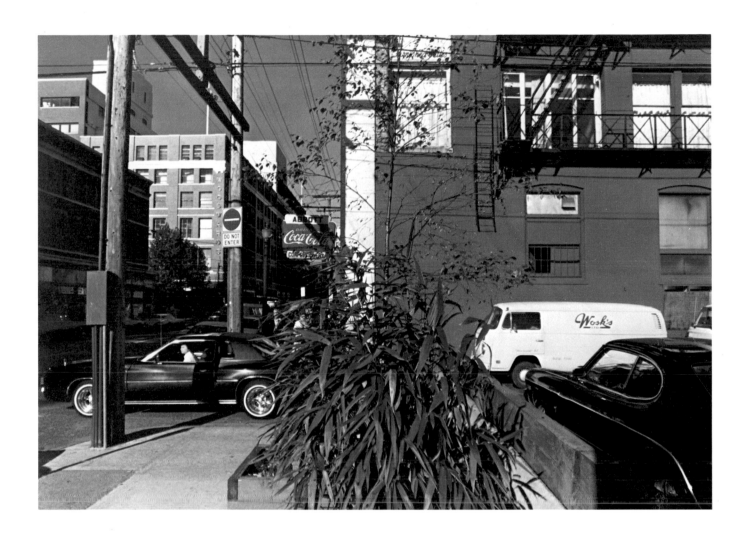

DAVID McMILLAN, Untitled, 1978

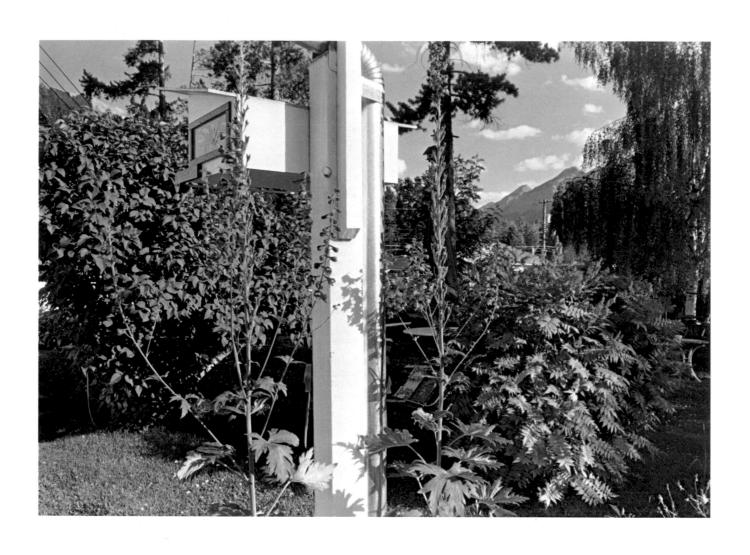

DAVID McMILLAN, Untitled, 1978

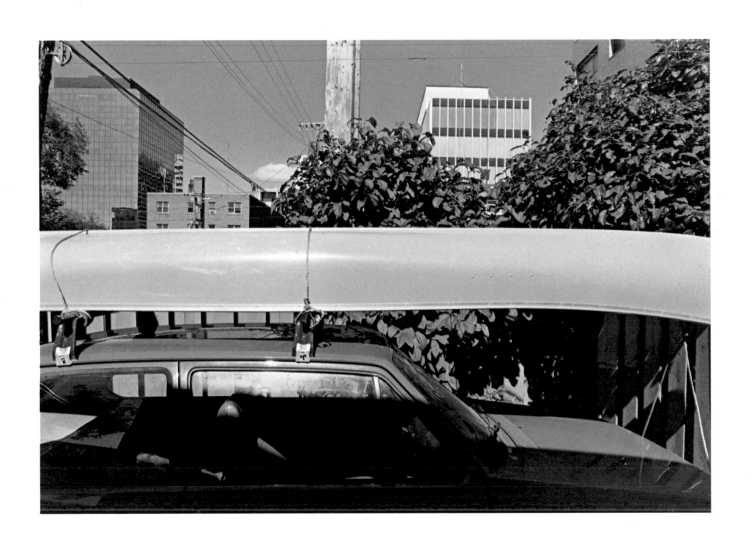

DAVID McMILLAN, Untitled, 1978

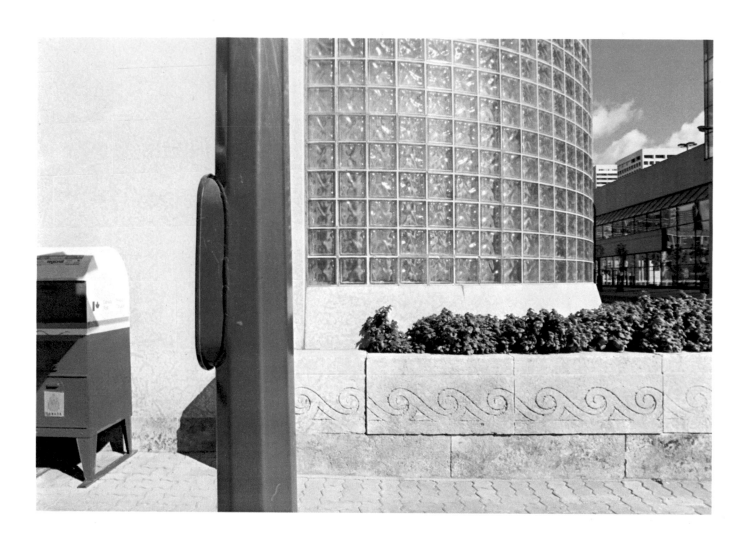

DAVID McMILLAN, Untitled, 1978

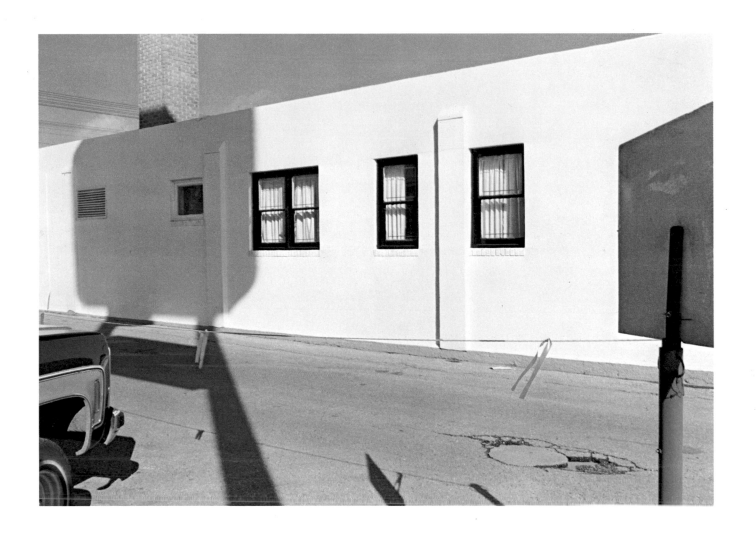

DAVID McMILLAN, Untitled, 1978

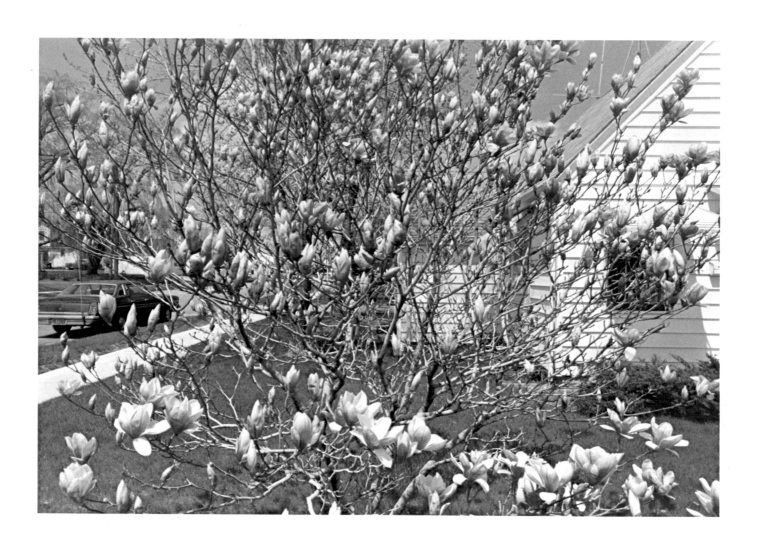

DAVID McMILLAN. Untitled. 1978

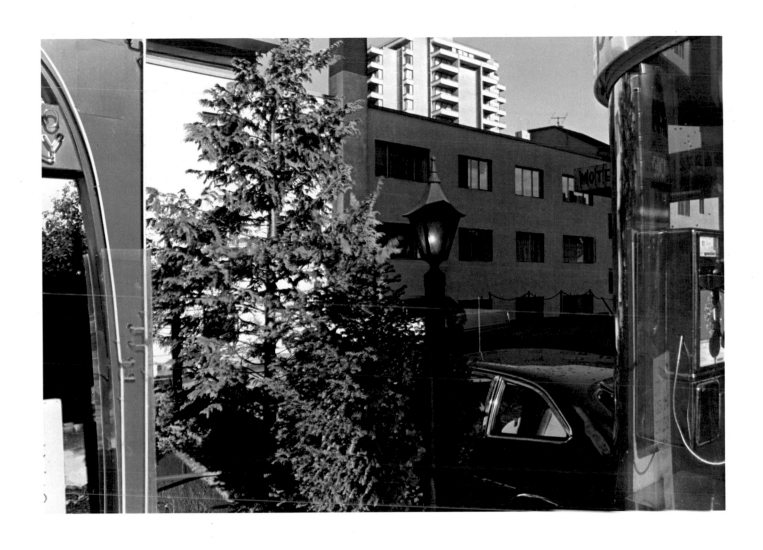

DAVID McMILLAN, Untitled, 1978

Nina Raginsky

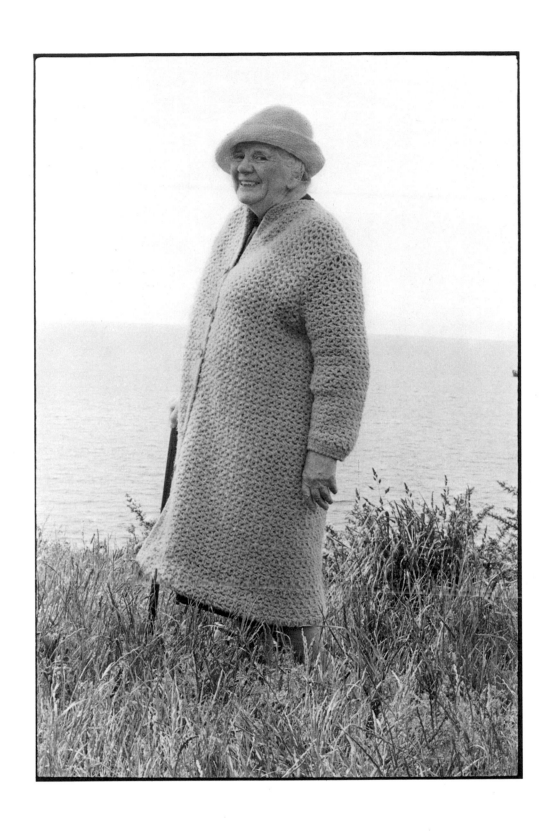

NINA RAGINSKY, Miss Eleanor Mitchell by the sea, Victoria, May 17, 1975

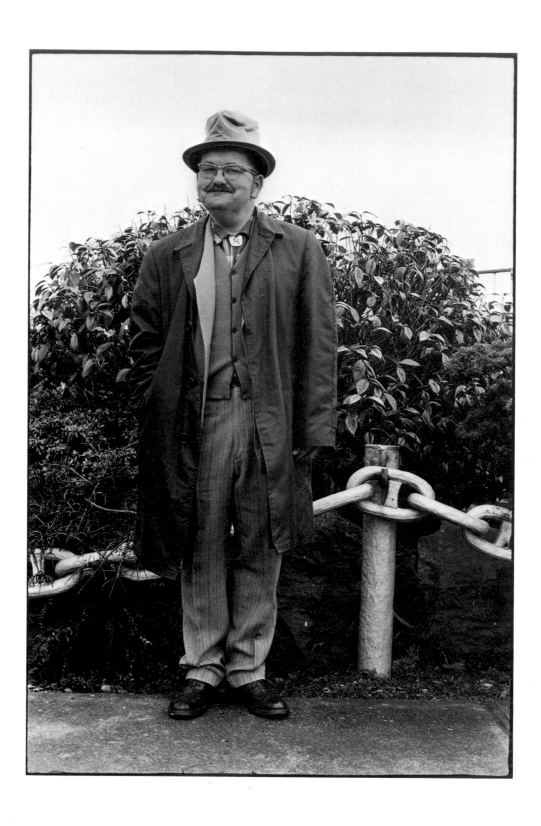

NINA RAGINSKY, Clarence Adamson on his way to lunch, Victoria, 1975

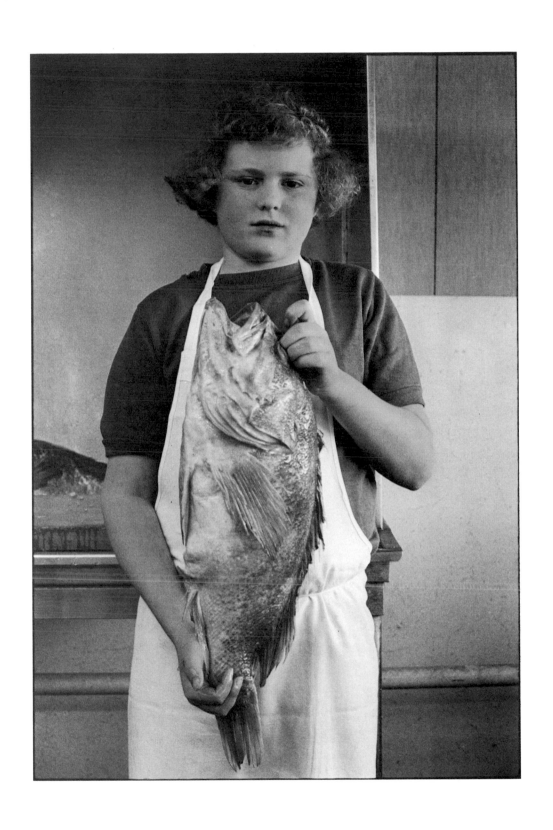

NINA RAGINSKY, Boy and Fish, Victoria, 1976

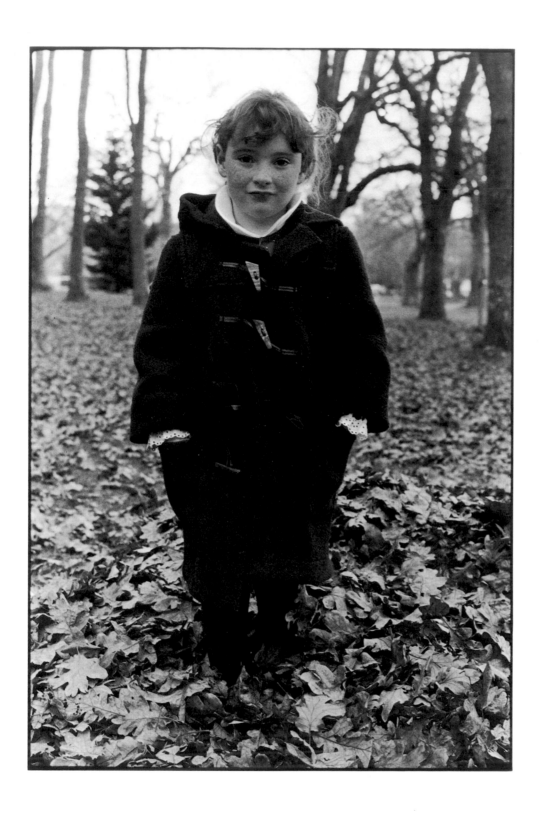

NINA RAGINSKY, Jennifer Taylor in Beacon Hill Park, Victoria, November 14, 1977

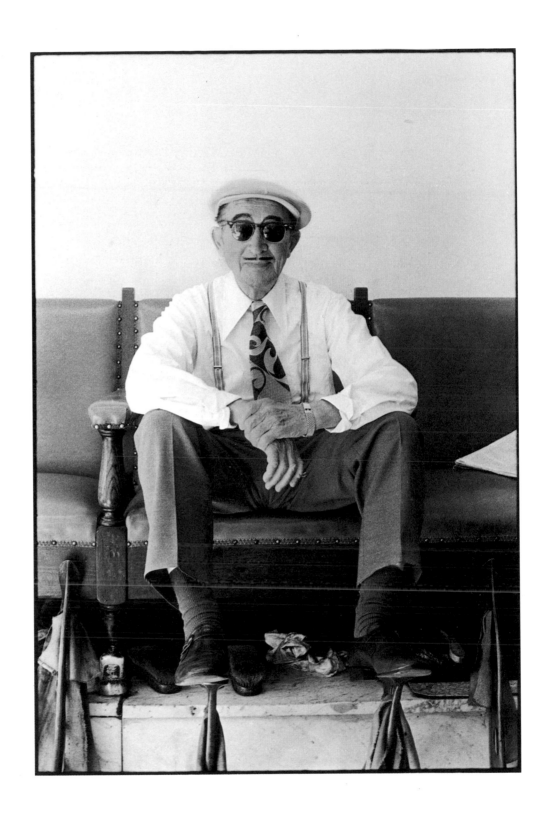

NINA RAGINSKY, Shoeshine Stand, Vancouver, 1974

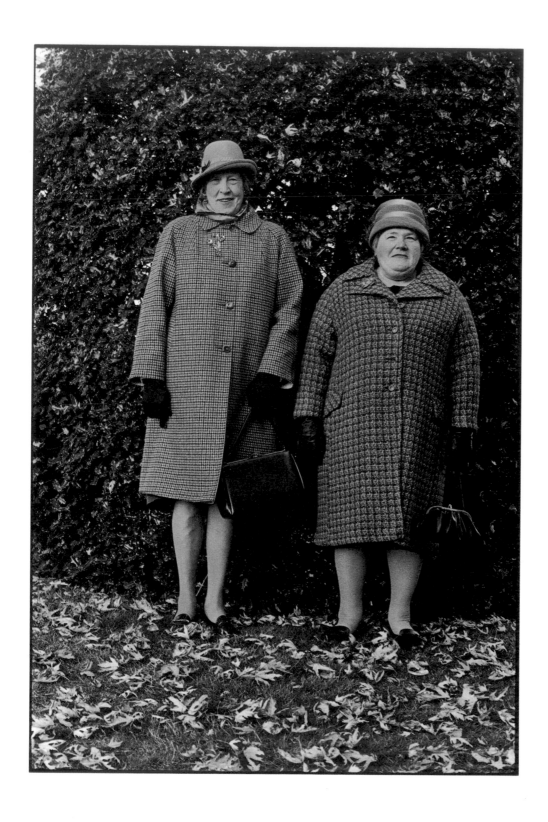

NINA RAGINSKY, The Kirkpatrick Sisters at The Empress Hotel, Victoria, 1975

Orest Semchishen

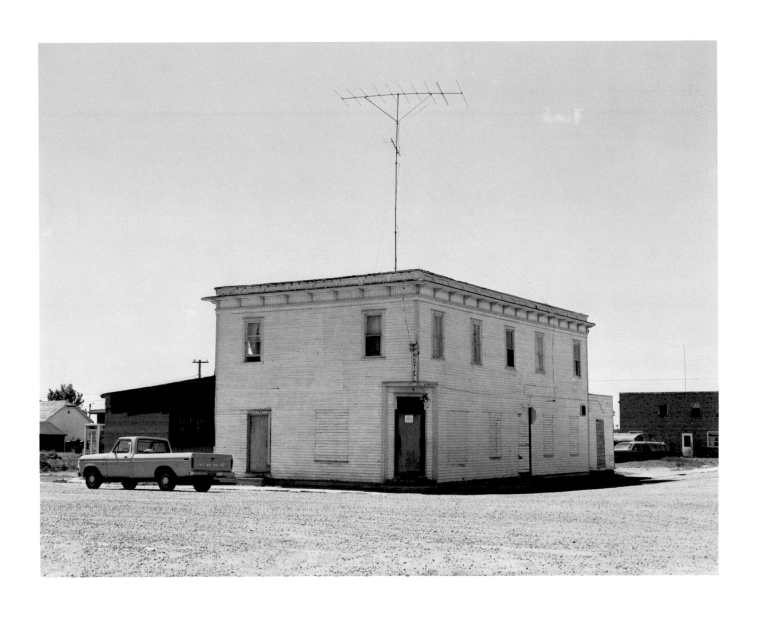

OREST SEMCHISHEN, Fort Kent, Alberta, 1977

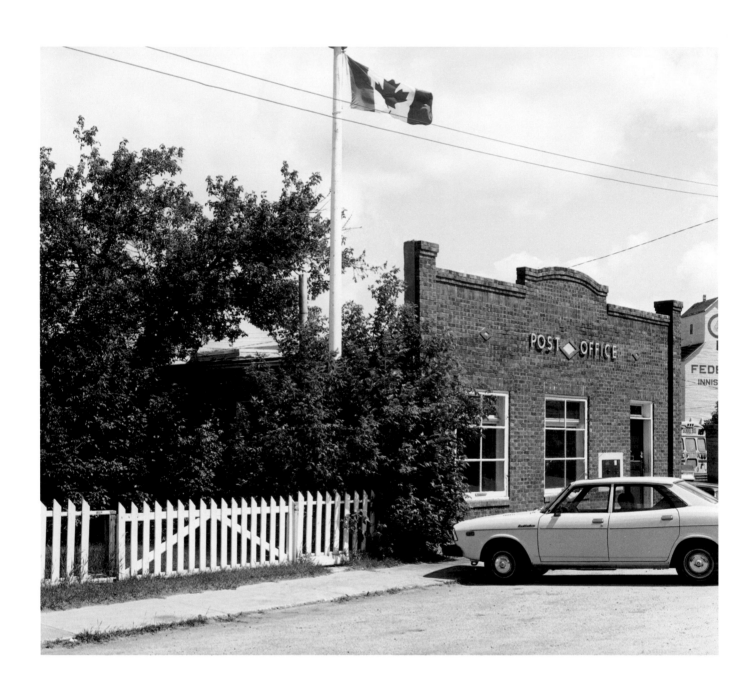

OREST SEMCHISHEN, Innisfree, Alberta, 1977

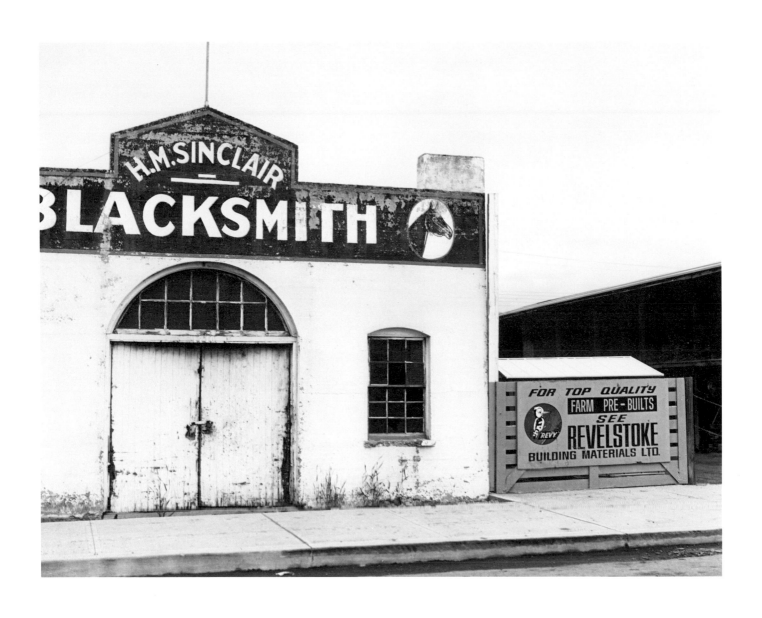

OREST SEMCHISHEN, Didsbury, Alberta, 1978

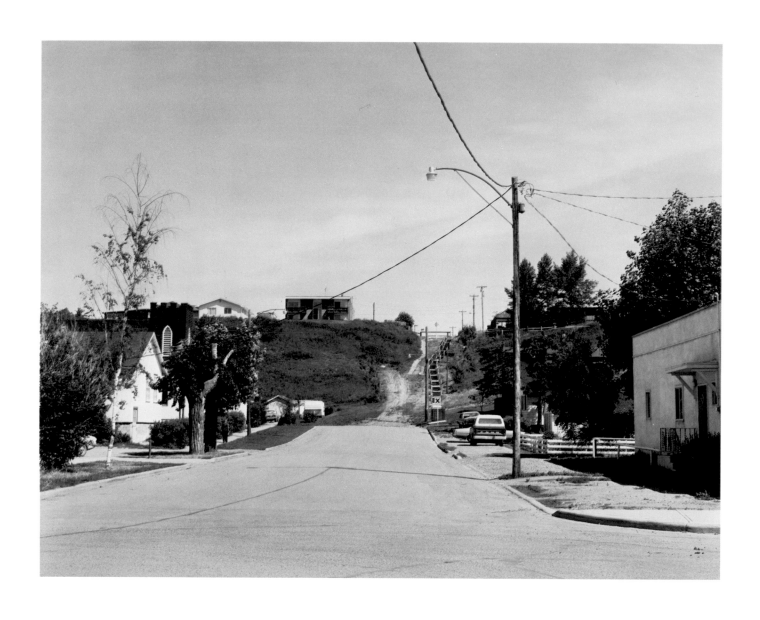

OREST SEMCHISHEN, Okotoks, Alberta, 1978

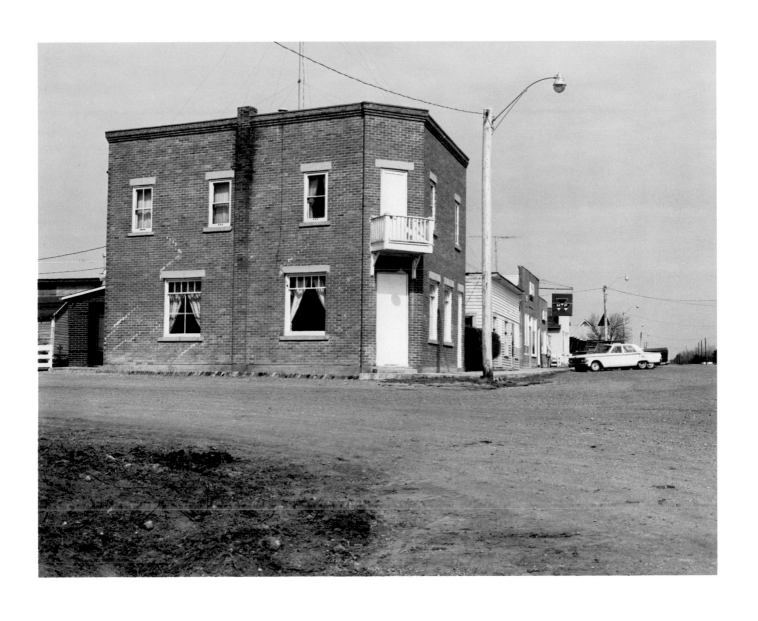

OREST SEMCHISHEN, Bellis, Alberta, 1978

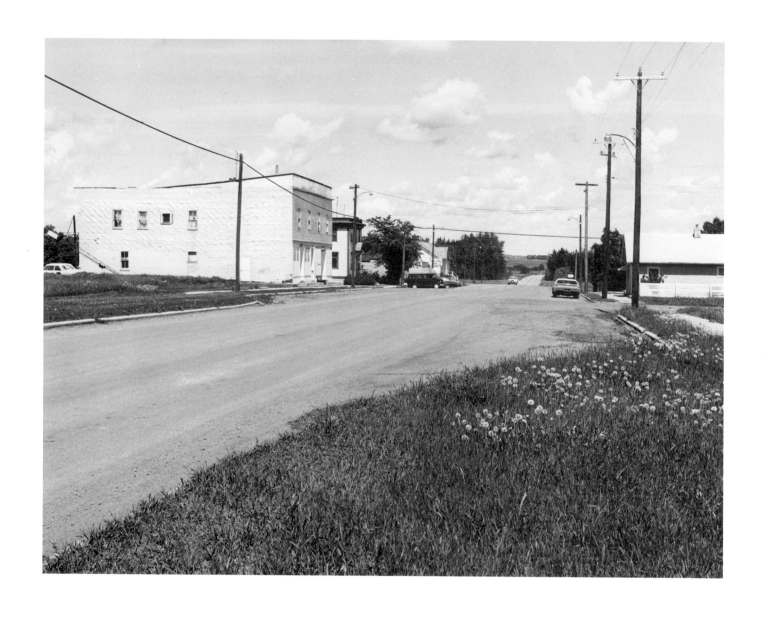

OREST SEMCHISHEN, Clive, Alberta, 1978

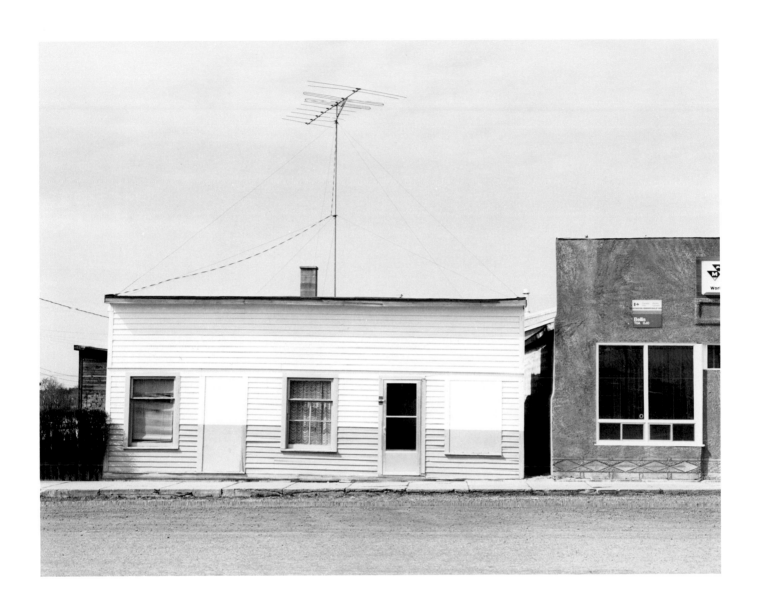

 OREST SEMCHISHEN, Bellis, Alberta, 1978

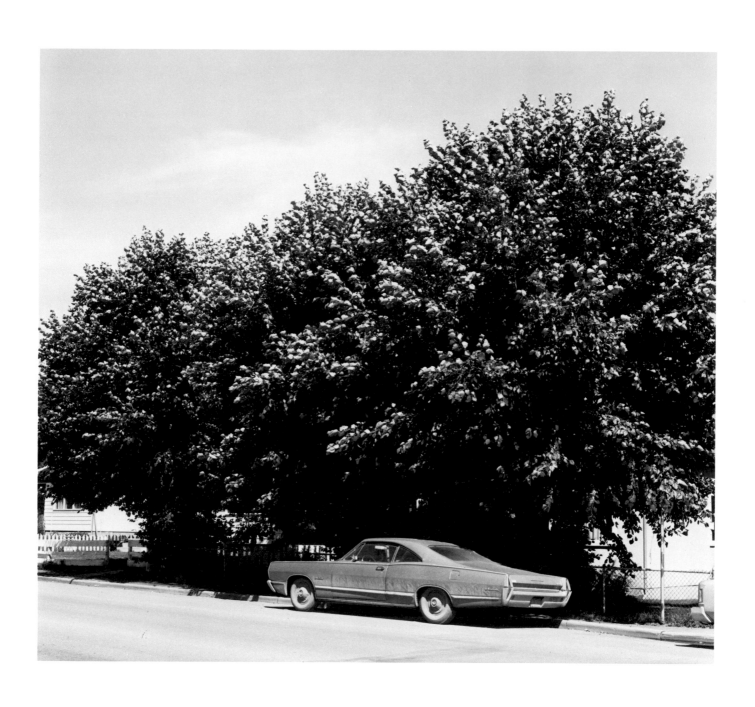

OREST SEMCHISHEN, Okotoks, Alberta, 1978

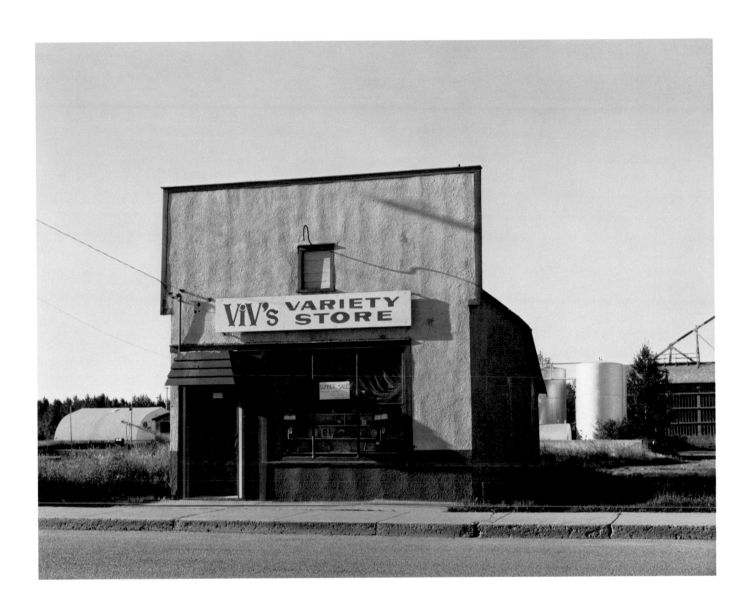

OREST SEMCHISHEN, Okotoks, Alberta, 1978

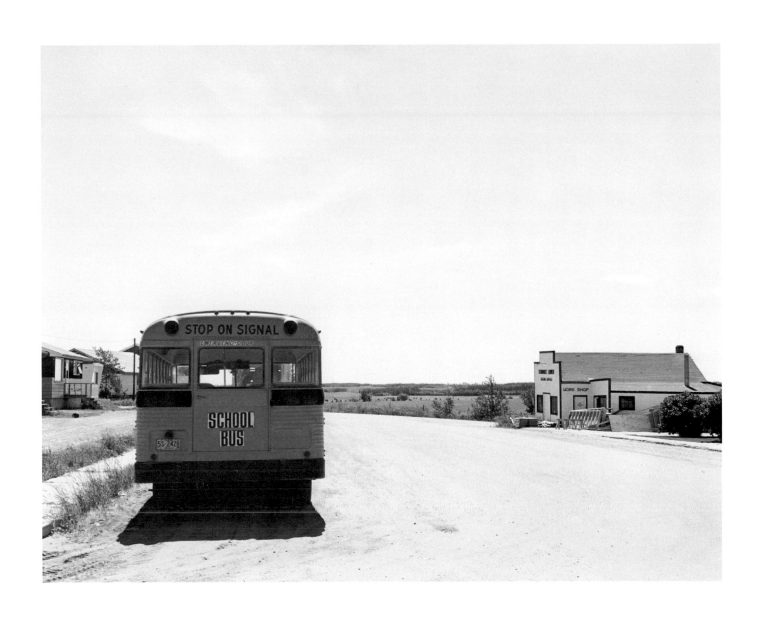

OREST SEMCHISHEN, Mallaig, Alberta, 1977

Robert Bourdeau

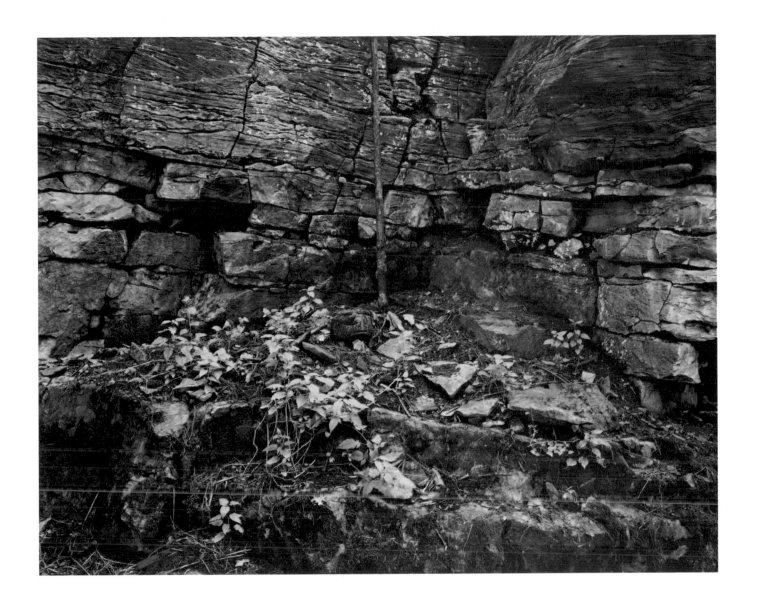

ROBERT BOURDEAU, Ontario, 1973

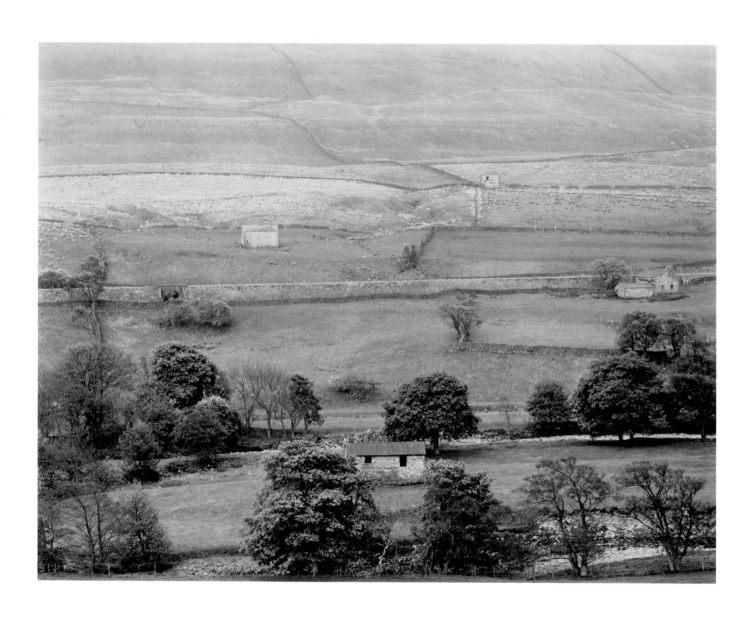

ROBERT BOURDEAU, England, 1975

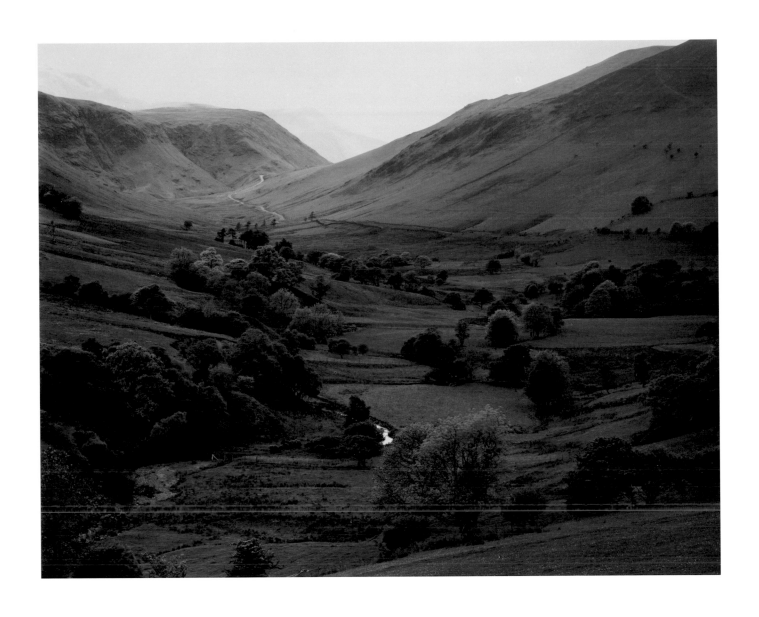

ROBERT BOURDEAU, England, 1975

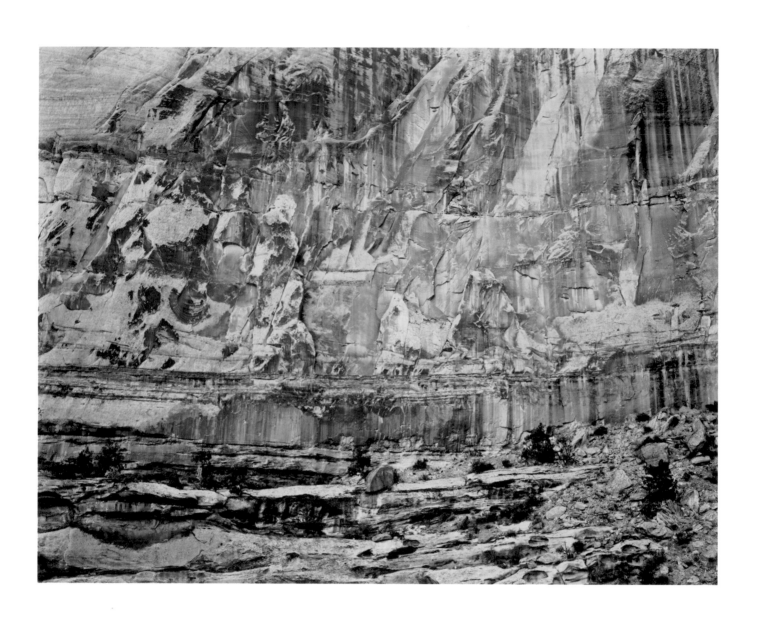

ROBERT BOURDEAU, Utah, 1976

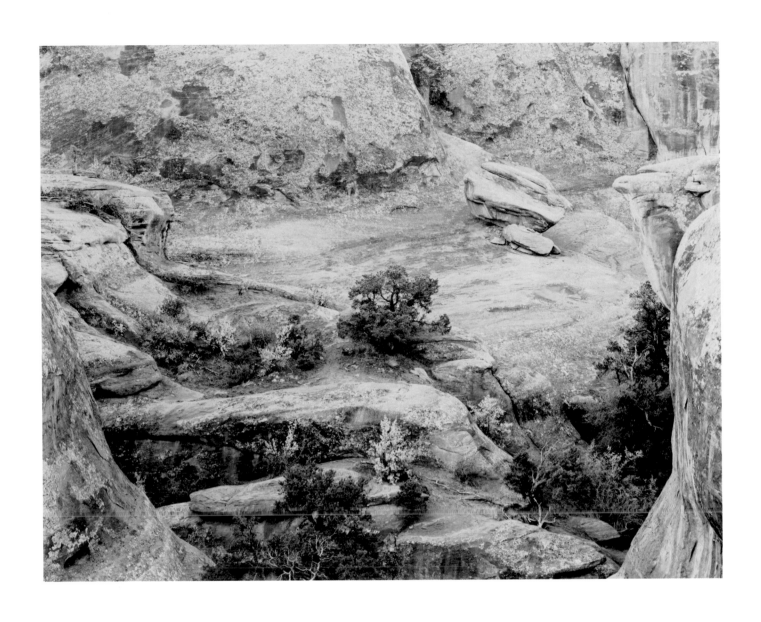

ROBERT BOURDEAU, Utah, 1976

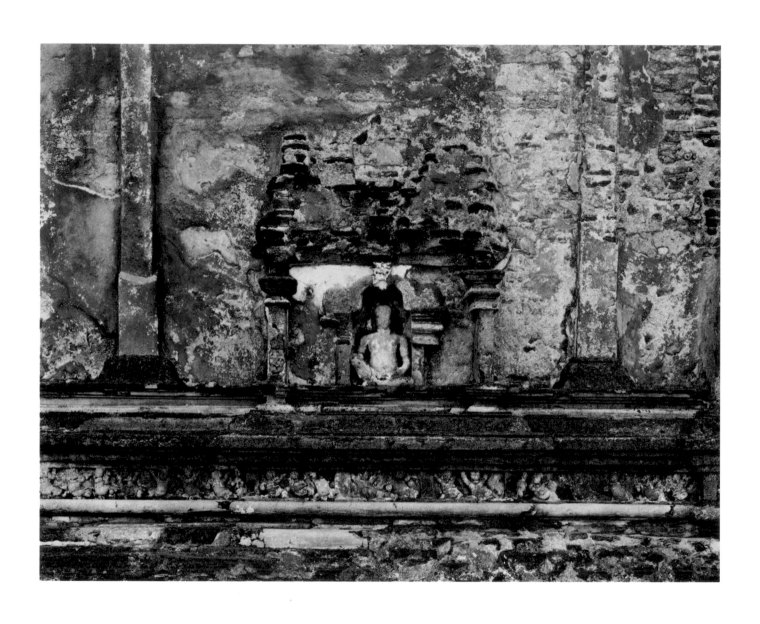

ROBERT BOURDEAU, Sri Lanka (Ceylon), 1978

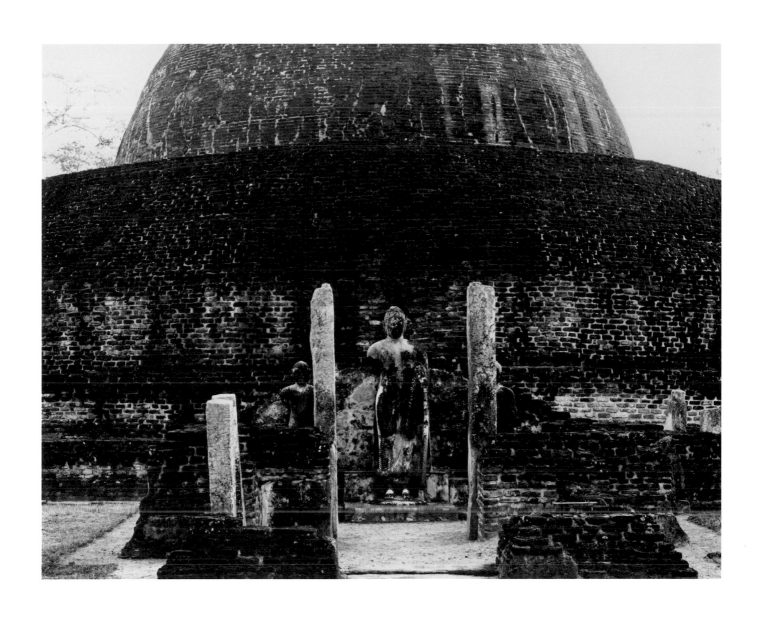

ROBERT BOURDEAU, Sri Lanka (Ceylon), 1978

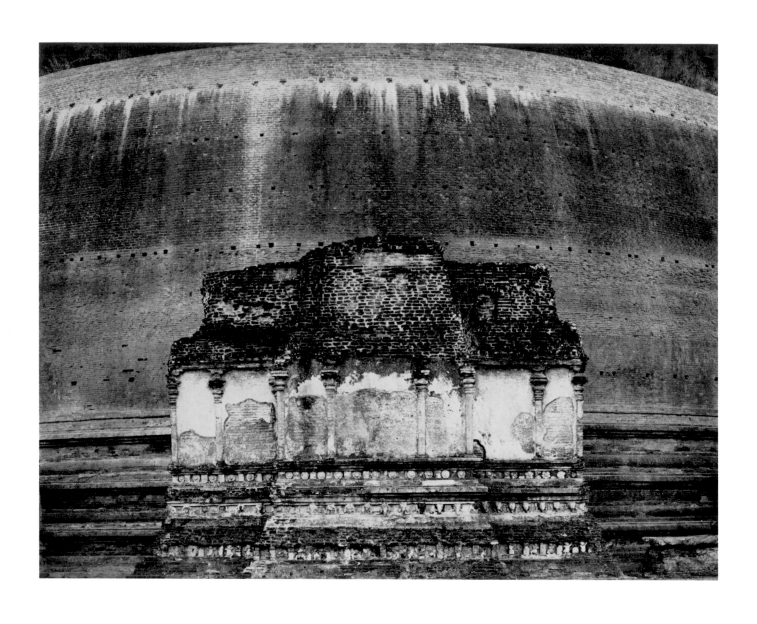

ROBERT BOURDEAU, Sri Lanka (Ceylon), 1978

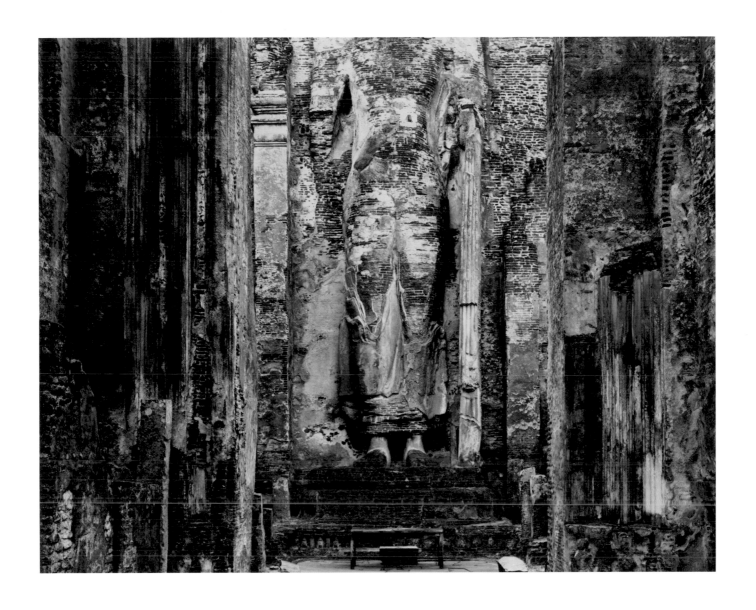

ROBERT BOURDEAU, Sri Lanka (Ceylon), 1978

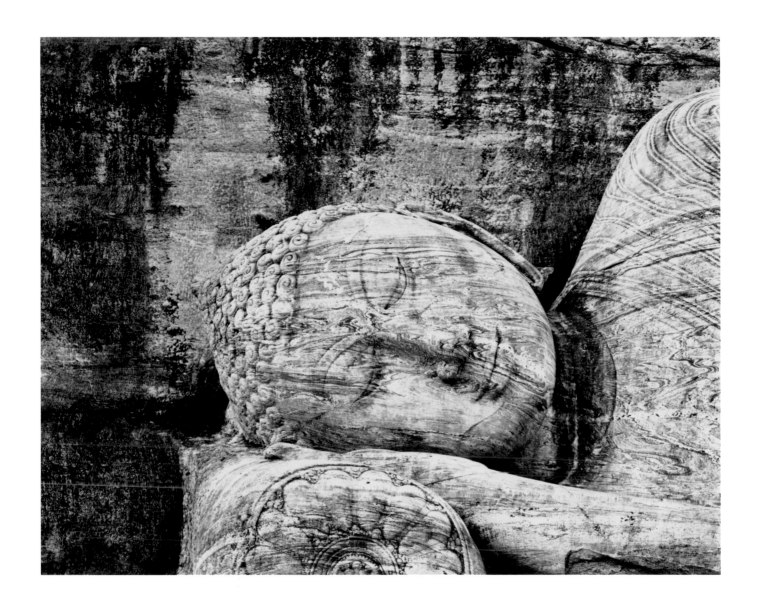

ROBERT BOURDEAU, Sri Lanka (Ceylon), 1978

Tom Gibson

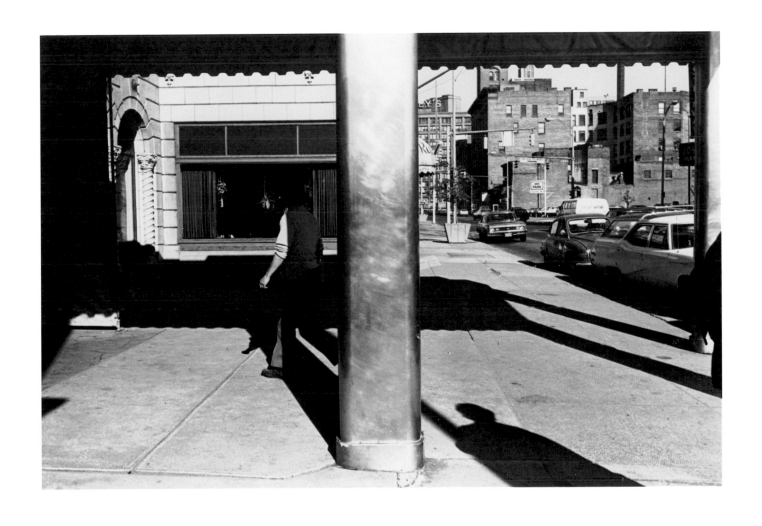

TOM GIBSON, Rochester, New York, 1976

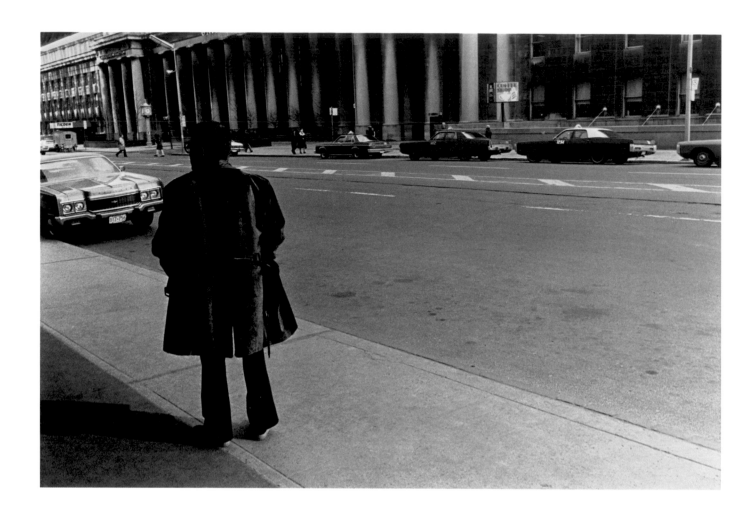

TOM GIBSON, Toronto, Ontario, 1976

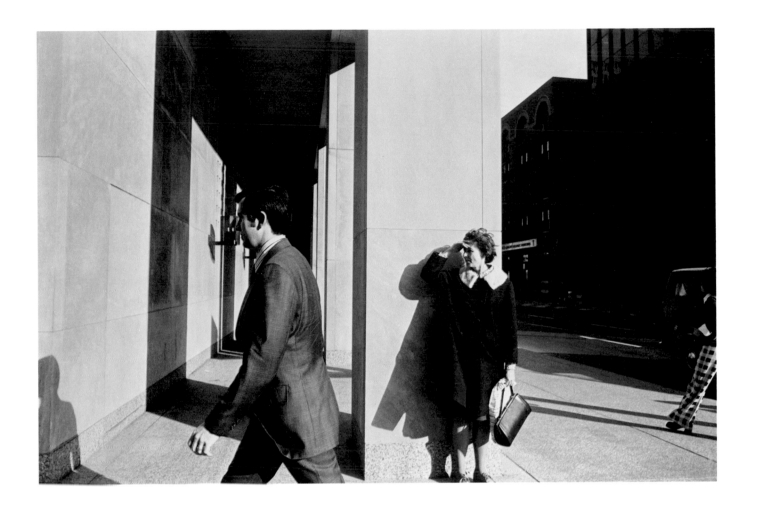

TOM GIBSON, Toronto, Ontario, 1975

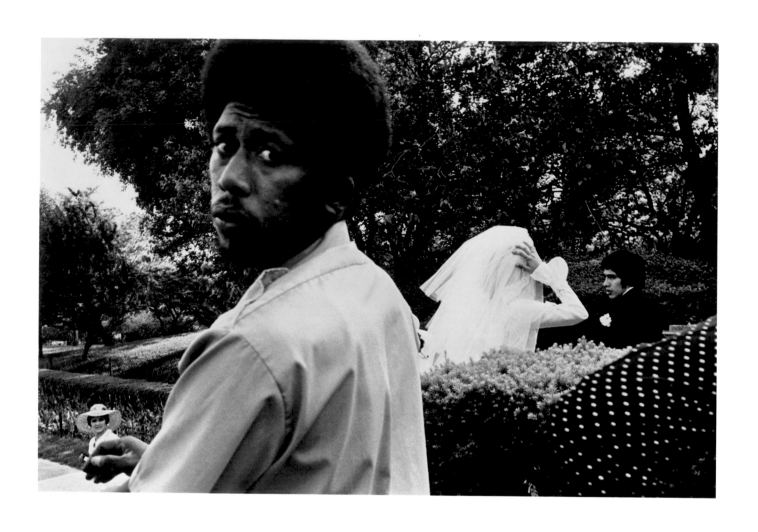

TOM GIBSON, Untitled, 1973

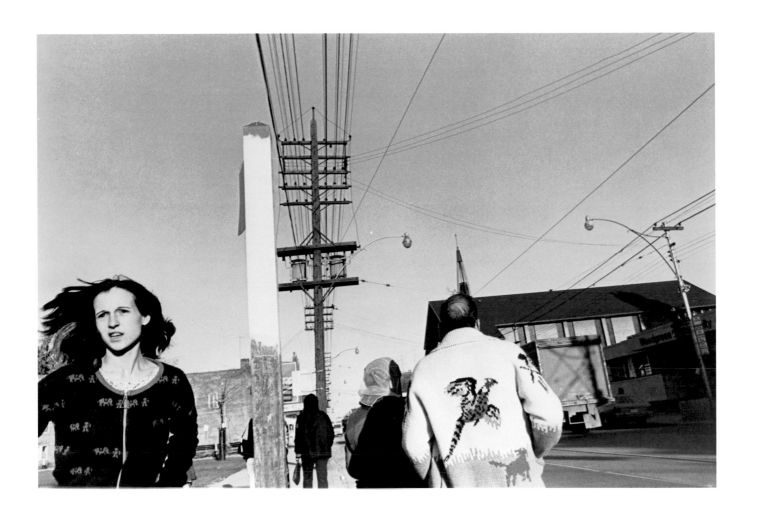

TOM GIBSON, Toronto, Ontario, 1973

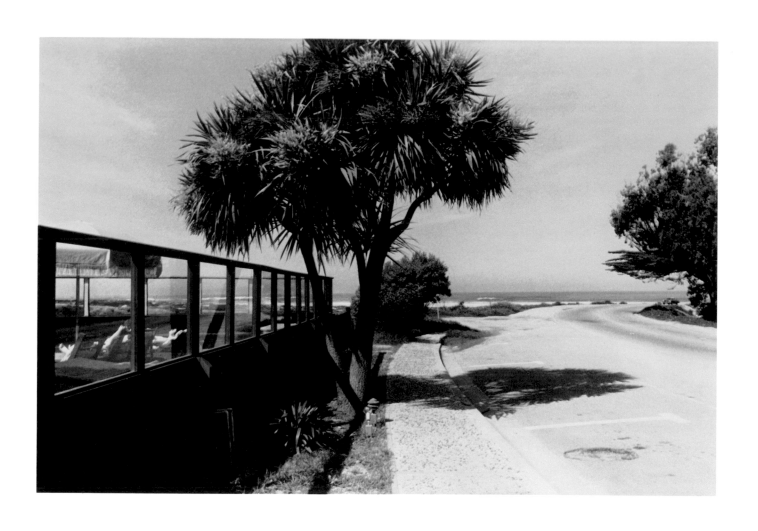

TOM GIBSON, Asilomar, California, 1978

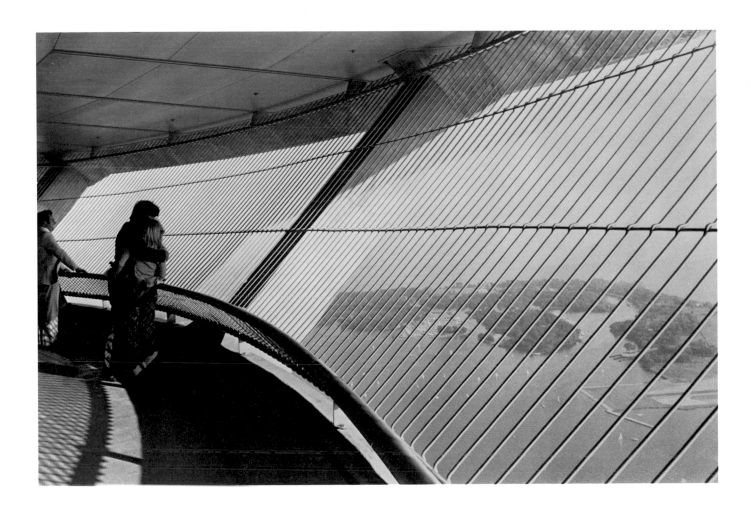

TOM GIBSON, Toronto, Ontario, 1976

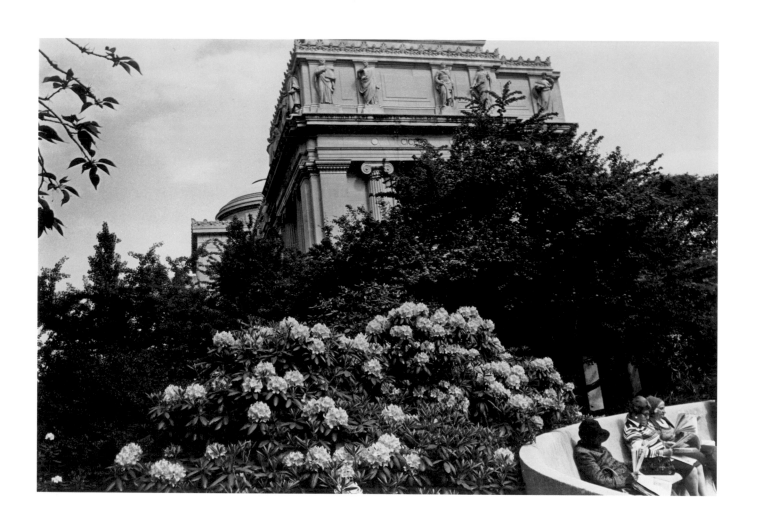

TOM GIBSON, Brooklyn, New York, 1973

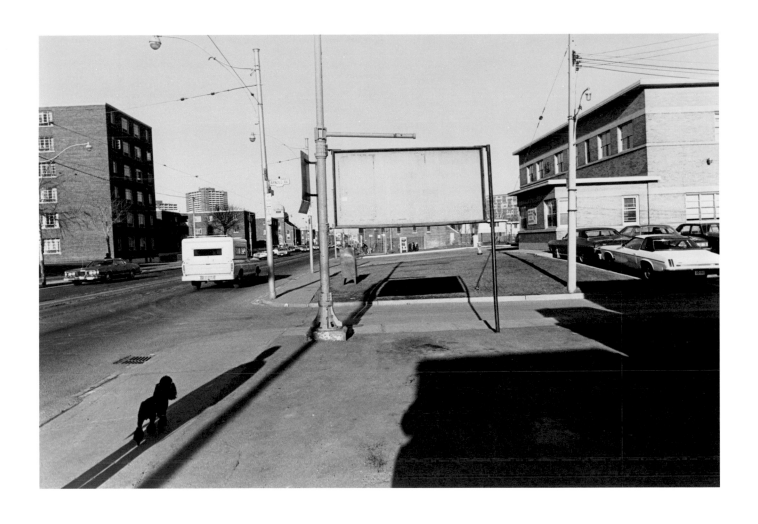

TOM GIBSON, Toronto, Ontario, 1976

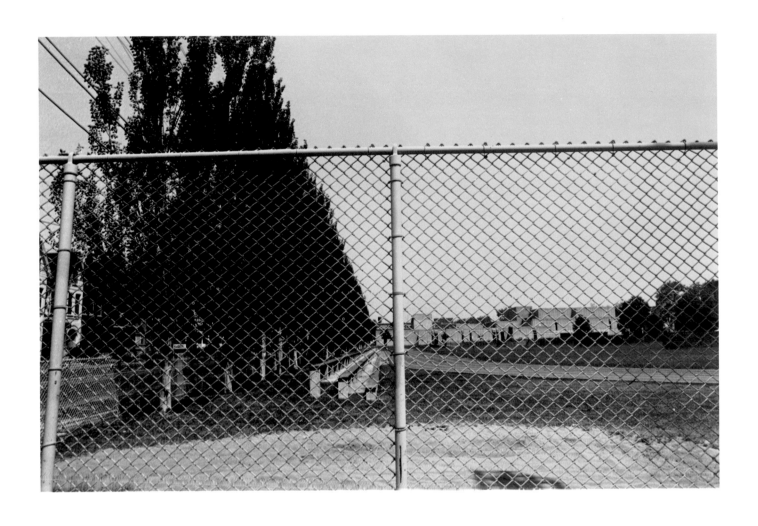

TOM GIBSON, Toronto, Ontario, 1976

Charles Gagnon

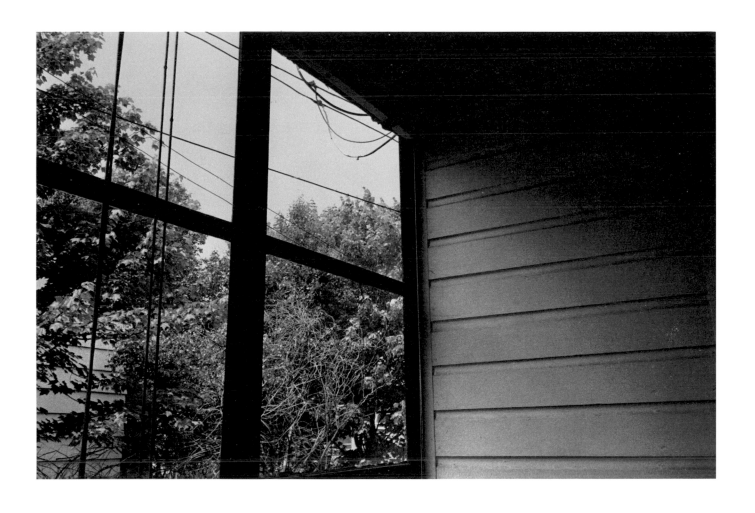

CHARLES GAGNON, New England, 1969

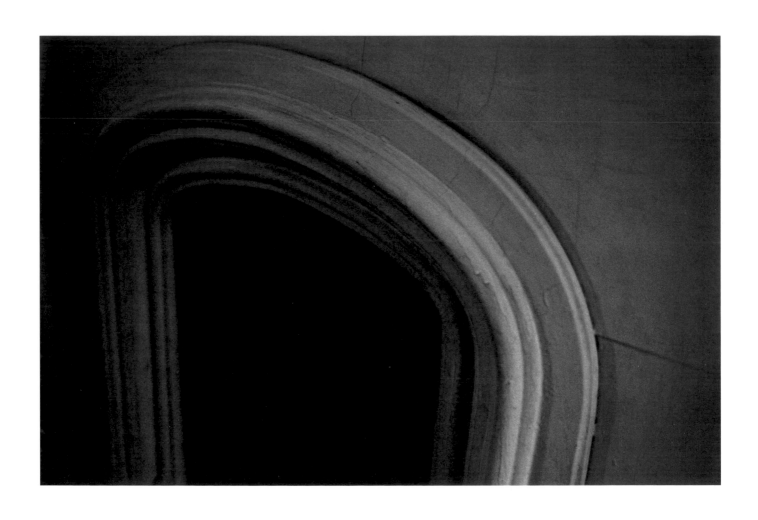

CHARLES GAGNON, Fireplace, New York, 1968

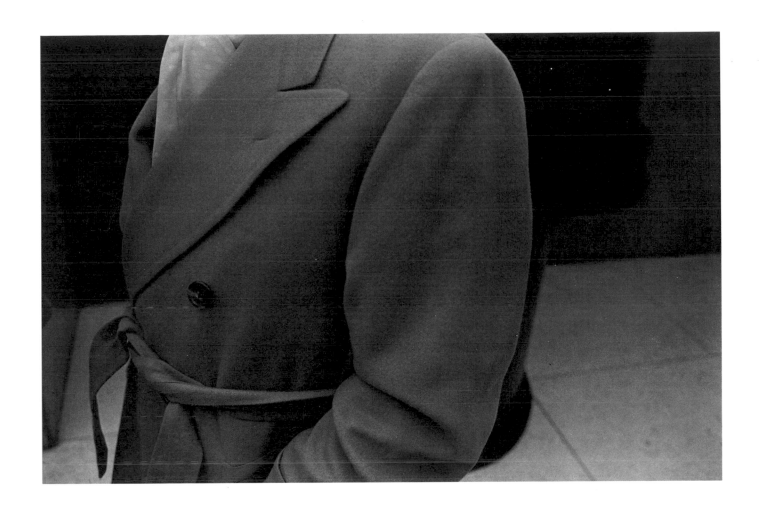

CHARLES GAGNON, Carl Mangold, Philatelist, 1970

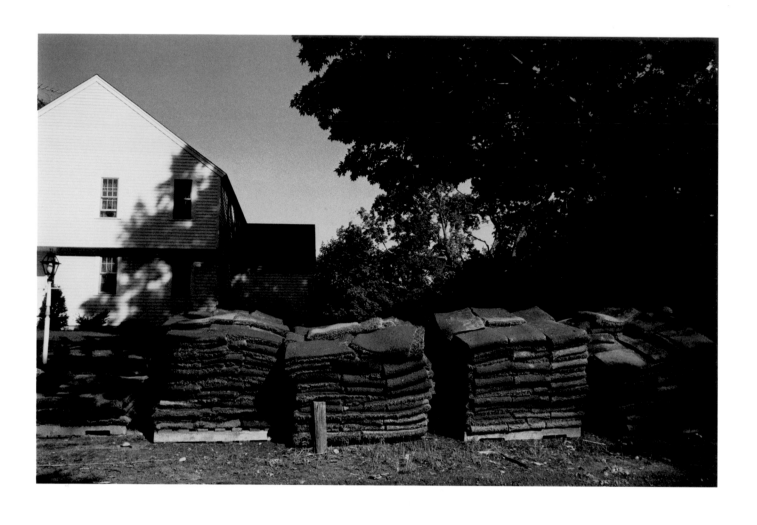

CHARLES GAGNON, Lawn, Norfolk, Connecticut, 1971

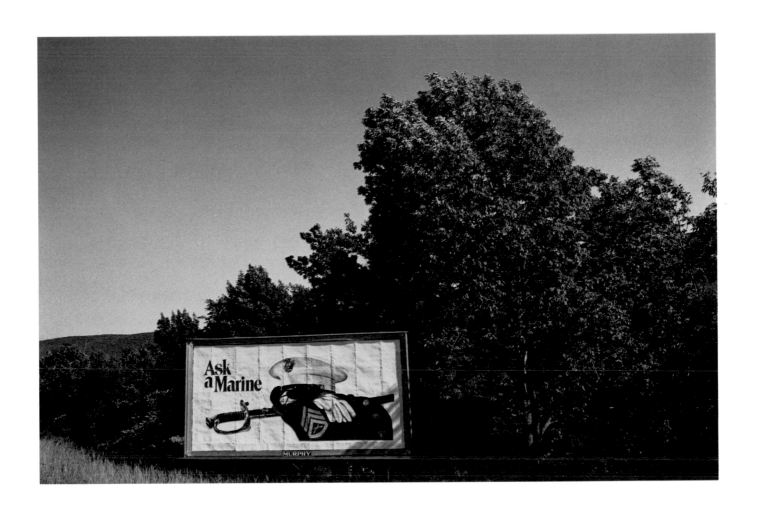

CHARLES GAGNON, Untitled, U.S.A., 1971

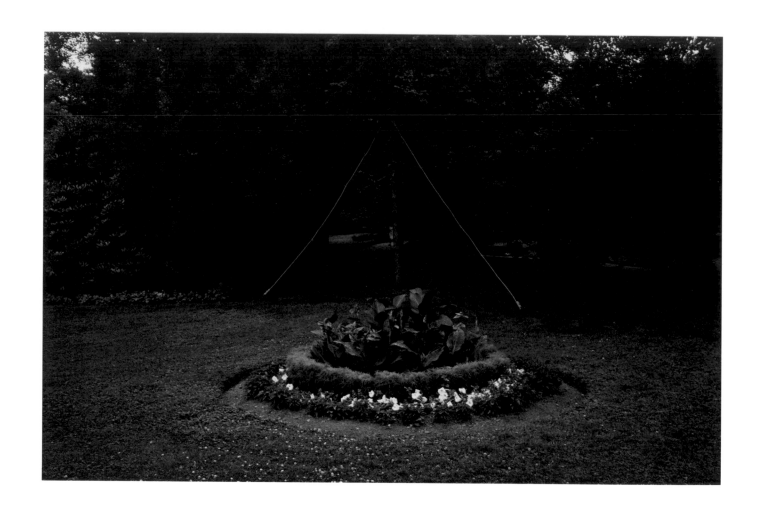

CHARLES GAGNON, Flowers, tree support — Halifax, 1974

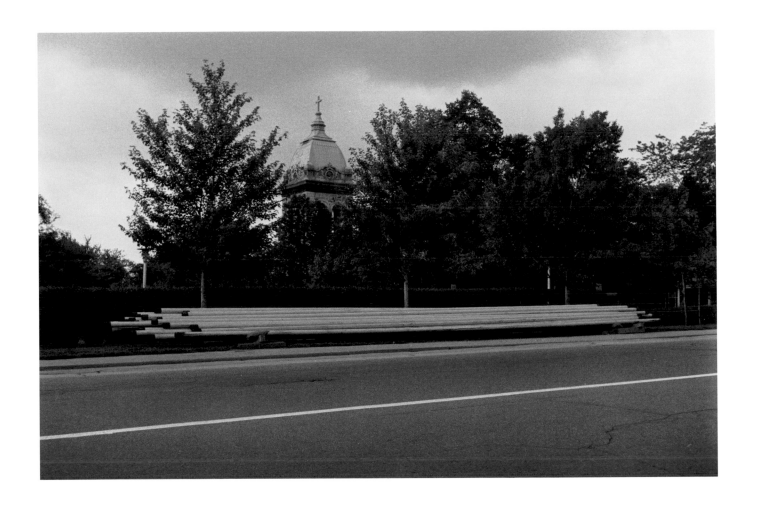

CHARLES GAGNON, Pipes, Park, Church — Montreal, 1972

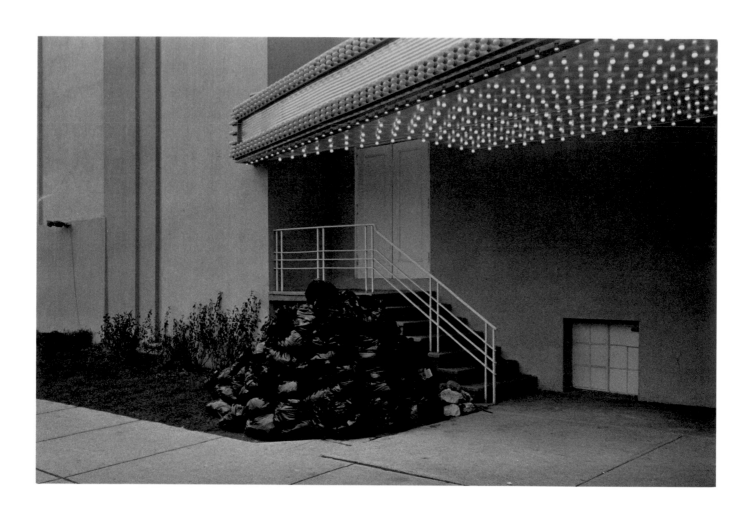

CHARLES GAGNON, Theatre marquee with garbage bags, 1973

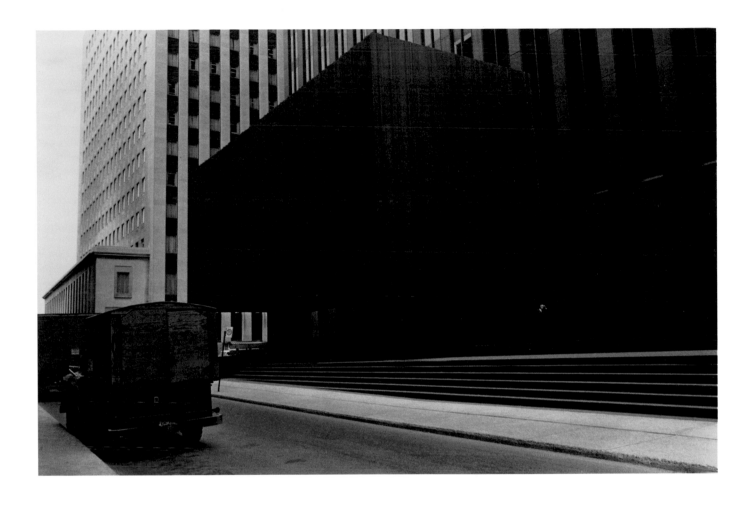

CHARLES GAGNON, Bank vault with truck and man — Montreal, 1973

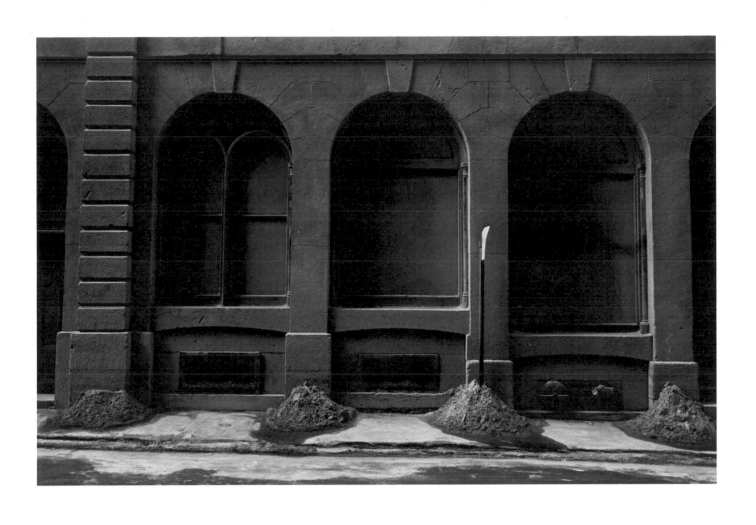

CHARLES GAGNON, Building after sand blasting — Montreal, 1977

Lynne Cohen

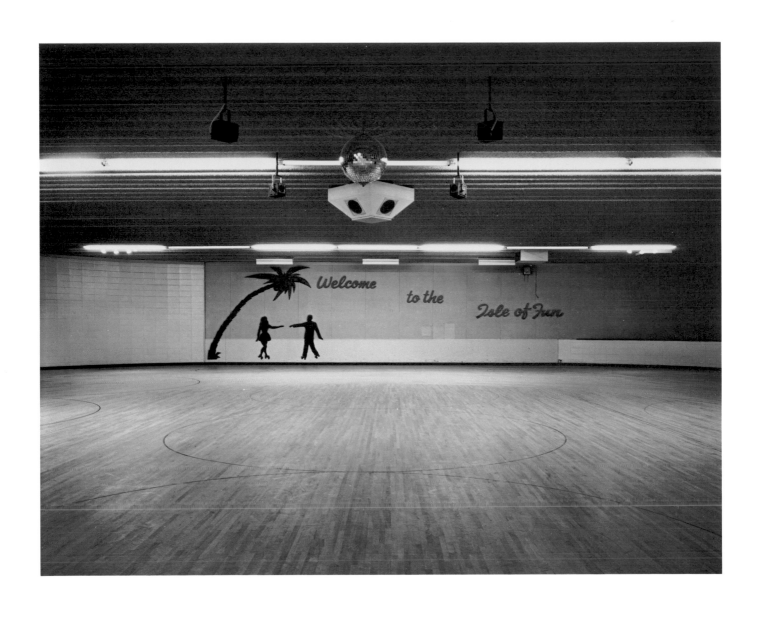

LYNNE COHEN, Isle of Fun, Skating Rink, Grand Island, Nebraska, 1975

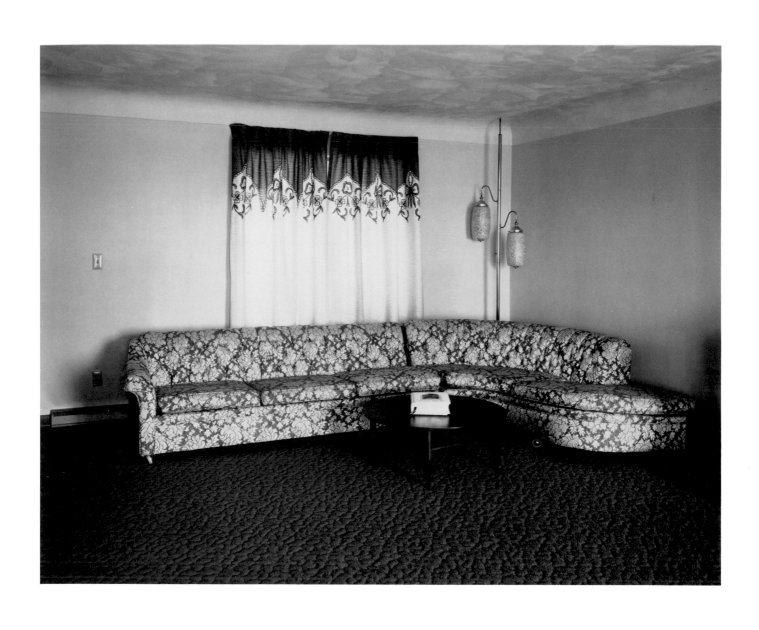

LYNNE COHEN, Living Room, Ann Arbor, Michigan, 1973

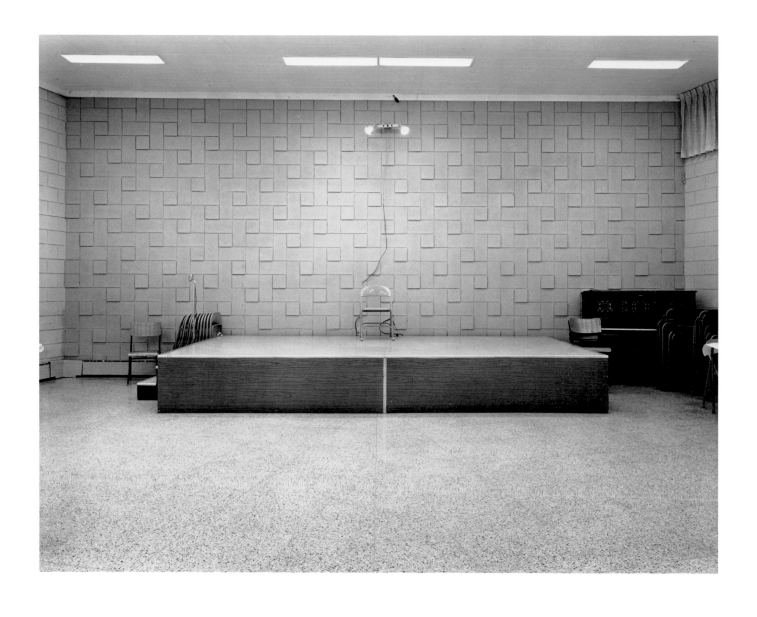

LYNNE COHEN, Knights of Columbus, Hamilton, Ontario, 1977

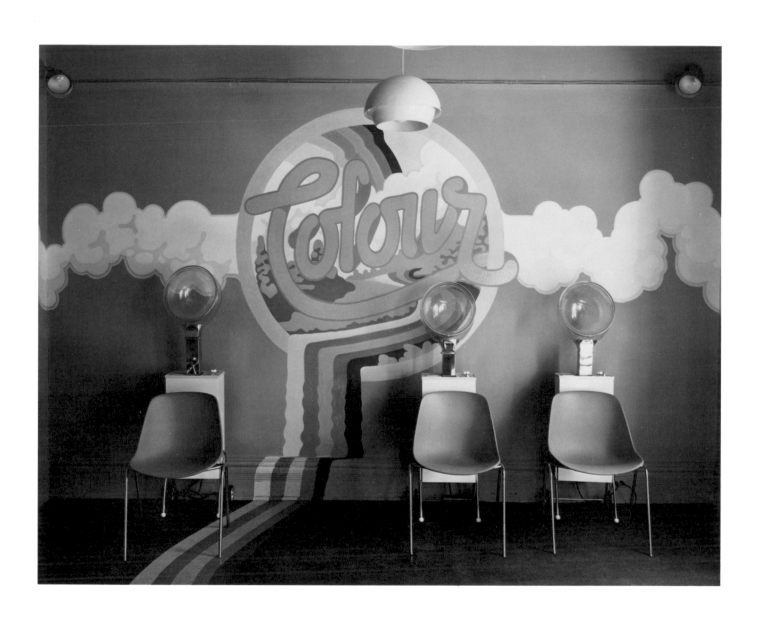

LYNNE COHEN, Beauty Salon, Ottawa, Ontario, 1977

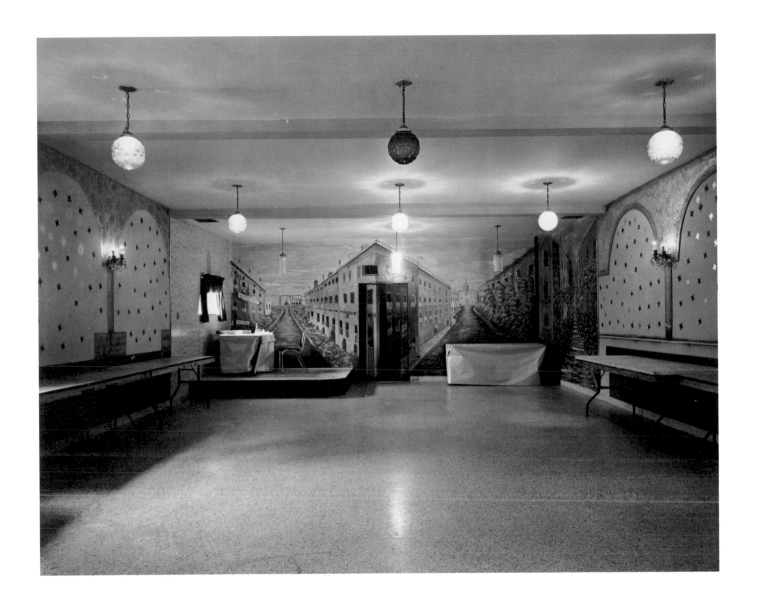

LYNNE COHEN, Italian Banquet Hall, Toronto, 1976

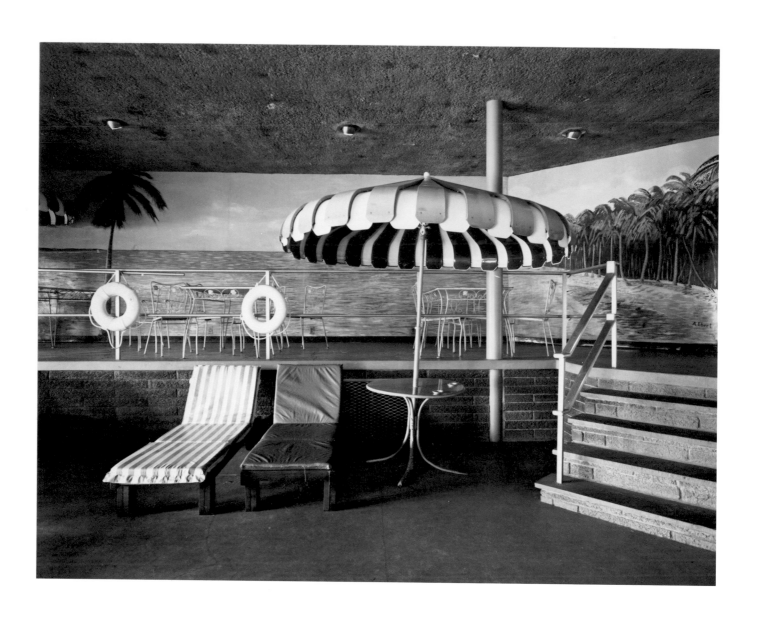

LYNNE COHEN, Swimming Pool, The Pocomont of the Poconos, Bushhill, Penn., 1975

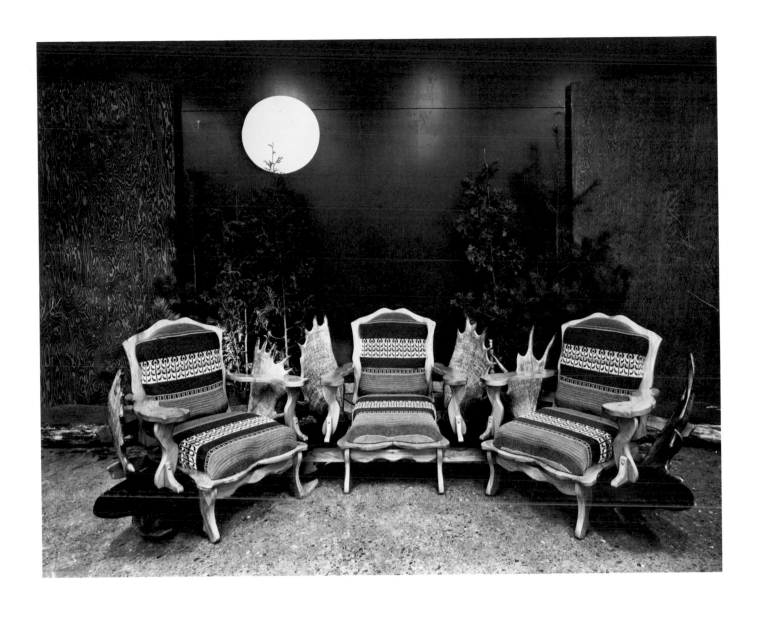

LYNNE COHEN, Camping Show, Place Bonaventure, Montreal, 1977

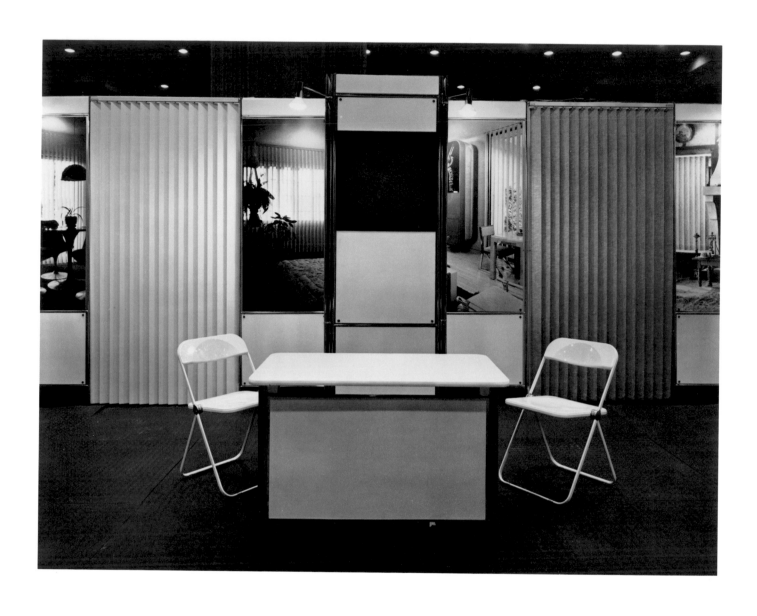

LYNNE COHEN, Exhibition Hall, Place Bonaventure, Montreal, 1978

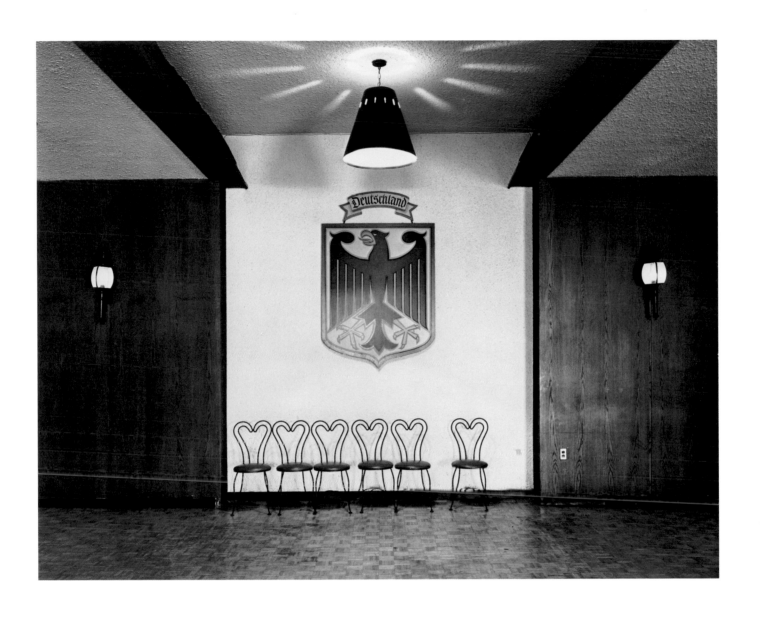

LYNNE COHEN, German Banquet Hall, Montreal, 1976

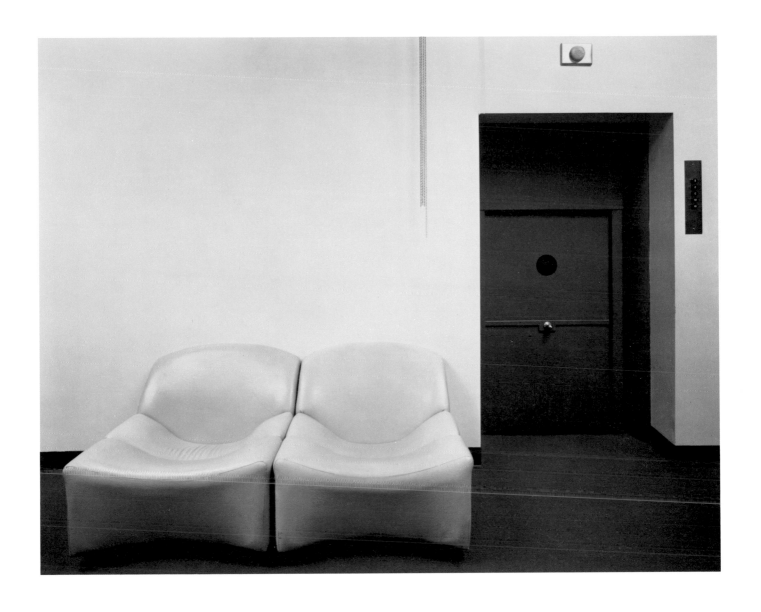

LYNNE COHEN, Ottawa Public Library, Ottawa, 1977

Born in Dundee, Scotland, 1945. Resides and works in Winnipeg, Manitoba; teaches at the University of Manitoba School of Art. M.F.A. from the University of Wisconsin, Madison, Wisconsin.

SELECTED EXHIBITIONS

1978 "Manitoba-Alberta-Saskatchewan," travelling group exhibition, National Film Board, *Ottawa, Ontario.*

1978 "Form and Performance," Winnipeg Art Gallery, *Winnipeg, Manitoba.*

1978 "Foto Fiction," Optica Gallery, *Montreal, Quebec.*

1977 "Three Photographers," Winnipeg Art Gallery, *Winnipeg, Manitoba.*

1976 "Forum 76," Montreal Museum of Fine Arts, *Montreal, Quebec.*

1975 "Exposure," Art Gallery of Ontario, *Toronto, Ontario.*

1974 "9 out of 10: A Survey of Contemporary Canadian Art," Art Gallery of Hamilton, *Hamilton, Ontario.*

SELECTED PERMANENT COLLECTIONS

Winnipeg Art Gallery, *Winnipeg, Manitoba*
Mendel Art Gallery, *Saskatoon, Saskatchewan*
National Film Board, *Ottawa, Ontario*
Edmonton Art Gallery, *Edmonton, Alberta*
Canada Council Art Bank, *Ottawa, Ontario*

David McMillan

Born in Montreal, Quebec, 1941. Resides in Victoria, British Columbia. Currently teaching at Emily Carr College of Art, Vancouver, British Columbia. B.A. from Rutgers University, New Jersey; studied with Roy Lichtenstein, George Segal and Allan Kaprow.

SELECTED EXHIBITIONS

1979 Individual exhibition, Vancouver Art Gallery, *Vancouver, British Columbia.*

1979 Individual exhibition, Edmonton Art Gallery, *Edmonton, Alberta.*

1979 Individual exhibition, Victoria Art Gallery, *Victoria, British Columbia.*

1979 Individual exhibition, Art Gallery of Ontario, *Toronto, Ontario.*

1978 "Sweet Immortality," group exhibition, Edmonton Art Gallery, *Edmonton, Alberta.*

1973 Individual exhibition, San Francisco Museum of Art, *San Francisco, California.*

1969 "Vision and Expression," group exhibition, Eastman House, *Rochester, New York.*

1968 International Photo Show, group exhibition, National Gallery, *Ottawa, Ontario.*

SELECTED PERMANENT COLLECTIONS
Edmonton Art Gallery, *Edmonton, Alberta*
Hartford Museum, *Connecticut*
Eastman House, *Rochester, New York*
National Gallery, *Ottawa, Ontario*
National Film Board, *Ottawa, Ontario*

Nina Raginsky

Born in Mundare, Alberta, 1932. Resides and works in Edmonton, Alberta. Self-taught in photography.

SELECTED EXHIBITIONS

1978 "Sweet Immortality," group exhibition, Edmonton Art Gallery, *Edmonton, Alberta.*

1977 Individual exhibition, Yajima/Galerie, *Montreal, Quebec.*

1977 Individual exhibition, Confederation Centre Art Gallery and Museum, *Charlottetown, Prince Edward Island.*

1976 Individual exhibition, Sir Alexander Galt Museum, *Lethbridge, Alberta.*

1976 "Byzantine Churches," individual exhibition, Edmonton Art Gallery, *Edmonton, Alberta.*

1975 "Ten Albums," group exhibition, National Film Board, Kent Street Gallery, *Ottawa, Ontario.*

SELECTED PERMANENT COLLECTIONS

Ukrainian Museum and Archives, *Winnipeg, Manitoba*
Edmonton Art Gallery, *Edmonton, Alberta*
Canada Council Art Bank, *Ottawa, Ontario*
Public Archives, *Ottawa, Ontario*
Alberta Art Foundation, *Edmonton, Alberta*
National Film Board, *Ottawa, Ontario*

Orest Semchishen

Born in Kingston, Ontario, 1931. Resides and works in Ottawa, Ontario. Self-taught in photography.

Robert Bourdeau

Born in Edinburgh, Scotland, 1930. Resides in Montreal, Quebec; Head of the Visual Arts Department at Concordia College, Montreal, Quebec. Studied at Visual Studies Workshop, Rochester, New York.

SELECTED EXHIBITIONS

1976 Individual exhibition, Yajima/Galerie, *Montreal, Quebec.*

1976 "Destination Europe," group exhibition originating at Optica Gallery, *Montreal, Quebec,* and travelling to Northern and Southern Europe.

1976 Individual exhibition, Loretta Yarlow Fine Arts Gallery, *Toronto, Ontario.*

1976 "Five Canadian Photographers," group exhibition, Owens Art Gallery, Mount Allison University, *Sackville, New Brunswick.*

1974 Individual exhibition, Centaur Gallery, *Montreal, Quebec.*

1972 Individual travelling exhibition, National Film Board, *Ottawa, Ontario.*

1971 Individual exhibition, Light Impressions Gallery, *Rochester, New York.*

1969 Group exhibition, Visual Studies Workshop, *Rochester, New York.*

SELECTED PERMANENT COLLECTIONS
National Gallery of Canada, *Ottawa, Ontario*
National Film Board of Canada, Still Photography Division, *Ottawa, Ontario*
Visual Studies Workshop, *Rochester, New York*
Eastman House, Photographic Poster Collection, *Rochester, New York*
Canada Council Art Bank Collection, *Ottawa, Ontario*

Tom Gibson

Born in Montreal, Quebec, 1934. Resides in Montreal, Quebec and works in Ottawa, Ontario; professor of Fine Arts at the University of Ottawa. Painter, photographer and film-maker.

SELECTED EXHIBITIONS

1978 Individual exhibition, Montreal Museum of Fine Arts, *Montreal, Quebec.*

1976 Individual exhibition, Yajima/Galerie, *Montreal, Quebec.*

1976 "Destination Europe," a group exhibition originating at Optica Gallery, *Montreal, Quebec,* and travelling to Northern and Southern Europe.

1976 "Five Canadian Photographers," group exhibition, Owens Art Gallery, Mount Allison University, *Sackville, New Brunswick.*

1973 Individual exhibition, York University, *Toronto, Ontario.*

1972 Individual exhibition, Mendel Art Gallery, *Saskatoon, Saskatchewan.*

1972 Individual exhibition, Sir George Williams University Art Gallery, *Montreal, Quebec.*

1972 "Five Montreal Photographers," group exhibition, Optica Gallery, *Montreal, Quebec.*

1971 Individual exhibition, Edmonton Art Gallery, *Edmonton, Alberta.*

1971 Individual exhibition, Vancouver Art Gallery, *Vancouver, British Columbia.*

SELECTED PERMANENT COLLECTIONS
National Gallery of Canada, *Ottawa, Ontario*
Musee des Beaux Arts, *Montreal, Quebec*
J. Hirshorn, *New York, New York*
Canada Council Art Bank, *Ottawa, Ontario*
Musee d'art Contemporain, *Montreal, Quebec*
Vancouver Art Gallery, *Vancouver, British Columbia*
Art Gallery of Ontario, *Toronto, Ontario*

Charles Gagnon

Born in Wisconsin, 1944. Resides and works in Ottawa, Ontario; teaches photography at the University of Ottawa. M.F.A. from Eastern Michigan University, Ypsilanti, Michigan.

SELECTED EXHIBITIONS

1978 Individual exhibition, International Center of Photography, New York, New York.

1978 "Silences et Stridences," two person exhibition, Galerie Nouvel Observateur/Delpire, *Paris, France.*

1976 "Photographer's Choice," group exhibition, Witkin Gallery, New York, New York.

1976 Group exhibition, Penthouse Gallery, Museum of Modern Art, New York, New York.

1976 "Destination Europe," group exhibition originating at Optica Gallery, *Montreal, Quebec*, and travelling to Northern and Southern Europe.

1976 "Five Canadian Photographers," group exhibition, Owens Art Gallery, Mount Allison University, *Sackville, New Brunswick.*

1975 Individual exhibition, Yajima/Galerie, *Montreal, Quebec.*

1975 Group exhibition, Art Gallery of Ontario, *Toronto, Ontario.*

1975 Individual exhibition, University of New Mexico, *Albuquerque, New Mexico*

1973 Individual exhibition, A Space Gallery, *Toronto, Ontario*

SELECTED PERMANENT COLLECTIONS
Bibliotheque National de Paris, *Paris, France*
National Gallery of Canada, *Ottawa, Ontario*
Canada Council Art Bank, *Ottawa, Ontario*
National Film Board of Canada, Still Photography Division, *Ottawa, Ontario*
International Museum of Photography, George Eastman House, *Rochester, New York*
Art Institute of Chicago, *Chicago, Illinois*
University of New Mexico, *Albuquerque, New Mexico*

Lynne Cohen

THE BANFF PURCHASE is a major project in photography that has been originated by The Walter Phillips Gallery and The Photography Department of The Banff Centre, School of Fine Arts. The principal elements of this project are: the acquisition of one hundred and fifty-three photographs by seven contemporary photographers (who are represented in this book) for The Banff Centre's permanent collection; the publication of this book as a document of the exhibition; the production of a teaching slide set of these photographs; and a Canadian Photographers Masterclass Series — a six week workshop featuring the exhibiting photographers as guest artists.

The realization of this project is the result of the efforts of many individuals and the contributions of a number of organizations. For their direct involvement and support, we would like to thank Dr. David Leighton, Director of The Banff Centre; Terry Fenton, Director/Curator of The Edmonton Art Gallery; Duncan Cameron, Director of The Glenbow Museum; NelsonVigneault, the designer for the exhibition; and Scott Gordon, Bill Tilland, Barbara Spohr and Bob Brunelle for their labours. We would like to thank Penny Cousineau specially for writing the introductory text for this book. To the countless others who contributed indirectly to this project, we say thank you.

We would like to acknowledge the important contribution by The Edmonton Art Gallery and The Glenbow Museum, who collaborated in the production of the exhibition. Finally, The Canada Council Art Bank, The Canada Council's Aid to Art Galleries Programme and The Museum Assistance Programmes of The National Museums of Canada are gratefully acknowledged for their contributions.

LORNE FALK AND HUBERT HOHN, CURATORS

Afterword